OPERAUPCLOSE

OperaUpClose and Vaughan Williams and Steven M. Levy
present the Olivier Award-winning production of

Puccini's

LA BOHÈME

DIRECTED AND IN A NEW ENGLISH VERSION BY ROBIN NORTON-HALE

First performed at The Cock Tavern Theatre on 8 December 2009

CAST

RODOLFO	Edward Hughes
	Philip Lee
	Gareth Morris
MARCELLO	Tom Bullard
	Nicolas Dwyer
	Tom Stoddart
MIMI	Susan Jiwey
	Rhona McKail
	Elinor Jane Moran
MUSETTA	Prudence Sanders
	Una Reynolds
COLLINE	Julian Charles
	Dickon Gough
SCHAUNARD	Marcin Kopec
	Alistair Sutherland
ALCINDORO	Martin Nelson
BENOIT	Chris Holwell
MUSETTA (selected dates) and BARMAID	Sarah Minns
CHORUS	Charlie Bannocks
	Marianne Hare
	Anthony Pinnick
	James Schouten
	Rebecca Shanks

PRODUCTION TEAM

DIRECTOR/LIBRETTIST	Robin Norton-Hale
MUSICAL DIRECTOR	Elspeth Wilkes
SET AND COSTUME DESIGN	Lucy Read
LIGHTING DESIGN	Richard Williamson
SET AND COSTUME DESIGN (Original production)	Kate Guinness Lucy Read
LIGHTING DESIGN (Original production)	Christopher Nairne
MUSICAL DIRECTOR (Original production)	Andrew Charity
ASSOCIATE MUSICAL DIRECTOR	Emily Leather
PRODUCERS	Dominic Haddock Adam Spreadbury-Maher Steven Levy Vaughan Williams
PRODUCER (Original production)	Ben Cooper
PRESS	Amanda Malpass
MARKETING	Jo Hutchison
PRODUCTION MANAGER	Jane Arnold-Forster
STAGE MANAGER	Checca Ponsonby
ASSISTANT STAGE MANAGER	Eloise Akehurst

CHARLIE BANNOCKS (CHORUS)

Charlie will be appearing in *The Seasoning House* directed by Paul Hyett as 'Villager girl' a sex trafficked Balkan girl, which premiered as the opening film in Film4's Frightfest in Leicester Square. She recently performed in *Shakespeare's Library* at The Barbican, as part of The RSC's World Shakespeare Festival. Theatre includes: Songstress in *Shakespeare's Library* (Strangeworks/The Barbican), Thel in *Visions of Tiriel and the Daughters of Albion* (Wilton's Music Hall), Chorus in *La Bohème* (OperaUpClose at Soho Theatre), Laddie in *The Lost Boys* (Future Cinema), Mia in *Kafka's Judgement* (RETZ's/ Somerset House), The Bride in *Blood Wedding*, Phoebe in *The Seance* and Eva in *Chatroom* (The Palace Theatre Westcliff). TV/ Film includes: *The Seasoning House* (Paul Hyett/ Sterling Pictures), Charlie in *Freak* (Dan Jerome Gill/Trail Blazer Pictures), and the small girl in *Felicia's Journey* (Atom Egoyan/ Icon/Alliance Altantis Pictures).

TOM BULLARD (MARCELLO)

Marcello/Schaunard *La Bohème* (OperaUpClose), Jack Rock *La Fanciulla del West* (OperaUpClose), Wilkins (cover) *Merrie England* (Opera South), Max *Demon Lover* (Grimeborn Festival), Figaro *The Barber of Seville* (OperaUpClose), Peter Ivanov *Zar und Zimmermann* (Opera South), Dandini *Cinderella* (OperaUpClose), Soldier *Alban* (Alban Community Opera), Smirnov *The Bear* (Minotaur Music Theatre), Piquillo (cover) *La Périchole* (Opera South). Baritone soloist in *Since it was the day...* (MacMillan) world premiere at Edinburgh International Festival (2011), recital of Haydn songs, duets and trios for Le Concert d'Astrée in Lille Opera House (2011), *Voices of Light* (Einhorn) with LSO and Marin Alsop (2011), *The Desert Music* (Reich) with LSO and Kristjan Järvi (2011), *The Cave* (Reich) with Ensemble Modern (2011). Competitor in the Wigmore Hall Kohn Foundation International Song Competition (2011), baritone soloist in Summer Opera Gala for Opera South with Ann Murray (2011), New Year's Opera Gala for Opera South (2011), Britten-Pears Young Artist, English Song Course, with Ann Murray and Ian Partridge (2010). Soloist with The City Waites, BBC4 documentary for Waldemar Januszczak (2010). Musical Director of The Allegri Singers (from 2008). Musical Director of the Swingle Singers (2004-2008). Teaches at Westminster Under School and St Paul's School for Boys.

JULIAN CHARLES (COLLINE)

Julian Charles studied singing with Adrian Thompson. He was a member of the Welsh National Opera Company for two years performing *Don Carlo, Der Fliegende Holländer, La Damnation de Faust, Tosca, Don Giovanni* and *Mazeppa*. Since then Julian has performed with leading ensembles and conductors across Europe such as Essa Pekka Salonen, Peter Schreier,

Gregor Nozvak, Jeffrey Tate, Carlo Rizzi and André de Ridder, the Philharmonia Orchestra, Royal Philharmonic Orchestra, Hamburg Symphony Orchestra, London Handel Players and London Mozart Players. In Recital he has sung at the Wigmore Hall, Oxford Lieder Festival and Chelsea Schubert festival. Last year Julian toured England, France and Switzerland with Diva Opera and this year England with Pavilion Opera. He has sung at Buxton Festival Opera, Opéra Municipale and recently the Soho Theatre in a production of *La Bohème* which won both an Olivier Award and Whatsonstage Award and is now revived at the Charing Cross Theatre with plans for performances in Dublin in 2013. Other plans include Handel *Messiah* (Peterborough Cathedral), Fauré *Requiem* (Norwich Cathedral), Beethoven *Symphony 9* (The Anvil Basingstoke/Royal Festival Hall), Elgar *The Dream of Gerontius* (Laeiszhalle Hambur), Verdi *Requiem* (Staatstheater Bamburg), Gounod *Mors et Vita* (Le Silo Marseille).

NICOLAS DWYER (MARCELLO)

Previously with OperaUpClose as Escamillo in *Carmen* and as Alidoro in *Cenerentola*. Nicolas has performed at Grange Park Opera as the Jailer in *Tosca*, the Herald in *Rigoletto* and as Captain Petrovich whilst covering the title role in *Eugene Onegin*. Roles elsewhere include Guglielmo in *Così Fan Tutte* (Situation Opera), Javert in *Les Misérables* (Pimlico Opera Prisons Project) and roles in contemporary operas at the Tête à Tête and Grimeborn opera festivals. Nick recently resumed studies at Guildhall School of Music and Drama.

DICKON GOUGH (COLLINE)

Dickon trained at LIPA, studied Opera at Birkbeck University and is a former member of the National Youth Choir of Great Britain. Recent credits include Pinellino *Gianni Schicchi* and *Lucia di Lammermoor* (Opera Holland Park), Masetto/Commendatore *Don Giovanni* (Opera della Luna), Viscomte Cascada *The Merry Widow* (Opera della Luna), Leporello *Don Giovanni* (Soho Theatre/OperaUpClose), Sergeant of Police *Pirates of Penzance*, (Kilworth House Theatre), Colline in OperaUpClose's Olivier Award-Winning *La Bohème* (Soho Theatre/OperaUpClose), Dr. Bartleby *The Barber of Seville (or Salisbury)* (OperaUpClose), Doctor/Baron Douphol *La Traviata* (Temple Place), Caiaphas *Jesus Christ Superstar* (Wyllyotts Theatre), Pirate/Policeman *Pirates of Penzance* (Regents Park/National Tour). Vocal work includes: Headlining with Mike and Kate Westbrook, 'Watching the River Flow' Festival; Guest Vocalist 'Safe From Harm' soundtrack (prod. Rollo Armstrong – Faithless), SXSW Music Festival in Austin, Texas with Blind Boris. Voiceovers for the Dreamworks animation of *Sinbad* and ADR for various Film/TV programmes including *The Tudors*, *The Borgias* and Ridley Scott's blockbuster *Robin Hood*.

MARIANNE HARE (CHORUS)

Marianne trained at Guildford School of Acting and has played the barmaid and been chorus captain in *La Bohème* with OperaUpClose at The King's Head in Islington and on tour. Previous work includes *Snow White* (Evolution Productions), Ophelia in *Hamlet* and Miranda in *The Tempest* (S4K, national tours), Glinda in *The Wiz* (Leatherhead Theatre), various characters in *A Christmas Carol* (Strangeface UK tour) and TMi with Sam and Mark (BBC).

CHRIS HOLWELL (BENOIT)

Chris has come to singing rather late in life and this is his first professional contract. He trained as an artist and spent the early 1990s leading the bohemian lifestyle as a struggling painter; during this time he first came into contact with opera as a prop maker at The Royal Opera House. He has spent the last twelve years as a self-employed builder. Upon reaching his 40th birthday and after a friend's suggestion he took up singing lessons and hasn't looked back since. Credits include Miles Gloriosus *A Funny Thing Happened On the Way to the Forum* (Brighton Little Theatre, 2009), Henchman *Die Rheinnixen* (New Sussex Opera, 2009), Il Commendatore *Don Giovanni* (Matchbox Opera, 2010), Usher *Trial by Jury* (New Sussex Opera, 2011), Colline *La Bohème* (Matchbox Opera, 2011), Morley Opera School roles in 2012 include Masetto, Aeneas, Krusina and Balstrode.

EDWARD HUGHES (RODOLFO)

Edward Hughes is a strong lyric tenor who enjoys success on both concert and opera stages. He studied at the Benjamin Britten International Opera School with Tim Evans-Jones, where he was supported by the Gisela Gledhill Award, Concordia Foundation, a Sybil Tutton Award administered by the Musician's Benevolent Fund, Wall Trust and Christopher & Susan Gordon-Wells Award. In 2012-13 roles include Cavaradossi in Puccini's *Tosca,* the title role in Monteverdi's *Orfeo* (Amadé players) and Florestan (Cover) in Beethoven's *Fidelio* (Midsummer Opera). Previous roles include Jenik in Smetana's *The Bartered Bride* and Tamino in Mozart's *The Magic* Flute (London Youth Opera), 1st Armed man in *The Magic Flute* and Ferrando (cover) in *Così fan tutte* (Longborough Festival Opera). Edward has given acclaimed performances of Schumann's *Dichterliebe* and Schubert's *Die schöne Müllerin* and sings recitals on a regular basis. He is also in demand as a concert soloist, singing repertoire including Mahler's *Das Lied von der Erde*, Beethoven's *9th Symphony*, Rachmaninov's *The Bells*, Elgar's *Dream of Gerontius* and Verdi's *Requiem*, with various ensembles including London Mahler Orchestra, Canterbury Choral Society, Royal Choral Society, London Philharmonic Orchestra and Berlin Philharmonic Orchestra. Edward enjoys choral singing and is a lay clerk at St. George's Cathedral, Southwark and a member of the Philharmonia Chorus Professional Singers

Scheme. For more information please visit www.edward-hughes.com.

SUSAN JIWEY (MIMI)

Susan Jiwey, a British soprano of Portuguese and Iraqi descent, graduated with distinction from the Guildhall School of Music and Drama. She is winner of the *Prix Bernac* for Best Singer at the Ravel International Academy. She was finalist in the Toulouse International Competition of French Song and the Mâcon International Opera Competition (the only non-French citizen to reach the finals). She is also an English-Speaking Union scholar. During 2012, Susan made her role debut as Cio Cio San *Madam Butterfly* (New Devon Opera) and joined Scottish Opera. In 2013 she will perform Britten's *Les Illuminations* (St Paul's Sinfonia) and make her role debut as Rosalinde *Die Fledermaus*. She studies with Susan McCulloch. Her busy stage career includes the roles of Mimi *La Bohème* at the Soho Theatre and subsequently with Woodhouse Opera. She has also sung Berta *The Barber of Seville* (Grange Park Opera, OperaUpClose), Dido *Dido and Aeneus* (Canbury Singers), Angelina *Trial By Jury* (Opera Minima), Musetta *La Bohème* (Opera de Baugé), Fidelia *Edgar* (Opera Valladolid), Donna Elvira *Don Giovanni,* Elettra *Idomeneo,* Arminda *La Finta Giardiniera,* Leila *Pêcheurs des Perles,* Adina *L'Elisir D'Amore,* Pamina *Die Zauberflöte* and the Handelian heroines of Cleopatra *Giulio Cesare,* Theodora and Alcina.

MARCIN KOPEC (SCHAUNARD)

Marcin graduated from the Vocal Faculty in Kraków and made his debut as Stolnik in *Halka* (St. Moniuszko). In 2007 Marcin moved to London and since then has worked for New Devon Opera, Opera Project, Pavilion Opera, Opera Brava, POSK, OperaUpClose, Unexpected Opera, Heritage Opera, Marinski Theatre, Aquarian Opera, WLO, SCO, Guildford Opera, Merry Opera, Opera and Operetta in Kraków, NOSPR, and Krakow Philharmonic. Operatic roles include Papageno *Magic Flute*, Belcore *L'elisir d'amore*, Janusz *Halka*, Figaro *The Barber of Seville*, Enrico *Lucia di Lammermoor*, Mercutio *Romeo and Juliet*, Schaunard *La Bohème*, Herald *The Burning Fiery Furnace*, Mars *Orpheus in the Underworld*, Dancairo *Carmen*, Stanislav *Verbum Nobile*, Count *Le nozze di Figaro*, Valentine *Faust* and others. Marcin participated in music festivals including Aix-en-Provence Festival, Schleswig–Holstein Festival, Wexford Festival Opera, Longborough Opera Festival Wratislavia Cantans working with world-acclaimed conductors: Y. Sado, M. Minkowski, K. Penderecki, Daniel Harding, Sylvain Camberling.

PHILIP LEE (RODOLFO)

Philip studied Music at Lancaster University before completing his training at Central School of Speech and Drama. Recent work includes Mr Snow in Opera North's *Carousel* at The

Barbican and Ernest in the first professional revival of Gilbert and Sullivan's last opera *The Grand Duke* at the Finborough. For OperaUpClose he has sung Rodolfo *La Bohème*, Almaviva *The Barber of Seville* and Arnalta in Mark Ravenhill's *The Coronation of Poppea*. Other roles include Tamino *The Magic Flute* (Mantissa Opera), Nadir *The Pearl Fishers* (Swansea City Opera UK Tour), Spoletta *Tosca* (Charles Court Opera), Lord Tolloller *Iolanthe* and Hilarion *Princess Ida* at the Buxton International G&S festival and a special performance of *The Yeomen of the Guard* at the Tower of London with Carl Rosa Opera. Theatre credits include the Max Miller bio *The Cheeky Chappie*, Will Scarlett in *Robin Hood* and Grendel in *Beowulf* for Charles Court Opera. He created the role of Vincent van Gogh in a new musical about the artist's life and his recorded work includes several new musicals and an album of new wedding songs.

RHONA MCKAIL (MIMI)

Rhona McKail, a student of John Evans, studied at the Royal Scottish Academy of Music and Drama and the Guildhall School of Music and Drama, completing her training on the opera course in 2009. Often performing on the concert platform, she has given recitals in the Purcell Room and St. Martin-in-the-Fields for the Park Lane Group, and will make her Wigmore Hall and Bridgewater Hall debuts in 2013. Rhona has worked on Education

projects for Scottish Opera, Leeds Lieder+, the Oxford May Music Festival and the Machynlleth Festival, introducing children to classical music and she has recorded Messiaen's *La Mort du Nombre* with Sholto Kynoch and Kaoru Yamada for Stone Records. Her Operatic roles include: Nannetta *Falstaff* (Opera Holland Park), Eurydice *Orpheus in the Underworld* (Scottish Opera), Angel 1 *Seven Angels* by Luke Bedford (The Opera Group), Servillia *La Clemenza di Tito* (English Touring Opera), Fiordiligi *Così fan Tutte* (Vignette Opera), Zerlina *Don Giovanni*; Hanna Glawari *The Merry Widow*; Josephine *HMS Pinafore*; Constance *The Sorcerer*; Adèle *Die Fledermaus* (Opera Della Luna), Anne Trulove *The Rake's Progress*; Gianetta *L'Elisir d'Amore* (British Youth Opera). Rhona has won many scholarships and prizes and is extremely grateful to all those who have supported her.

SARAH MINNS (MUSETTA [selected dates] and BARMAID)

Sarah Minns trained at the Royal Academy of Music and at the Royal Welsh College of Music and Drama. During her time in Cardiff Sarah held a vocal scholarship with the BBC and sang with Welsh National Youth Opera. As well as other important master classes, Sarah studied at the Juilliard School of Music, New York, under Dr Robert C White Jr. Sarah is also a trained dancer. She has

studied ballet for over 20 years. Opera credits include: Eleanor Vale *Eleanor Vale* (Wedmore Opera, World Premiere by John Barber), Bianca/Gabriella *La Rondine* (Opera Holland Park), Sprite *Fantastic Mr. Fox* (Opera Holland Park), Kate Pinkerton *Madam Butterfly* (OperaUpClose), Musetta *La Bohème* (WO), Santuzza *Cavalleria Rusticana* (WO), Carolina *Il Matrimonio Segreto*, Karolina *The Two Widows*, Fox *The Cunning Little Vixen* (RWCMD), Gretel *Hansel and Gretel* (RWCMD), Dido *Dido & Aeneas* (RWCMD), Miss Wordsworth *Albert Herring* (Welsh National Youth Opera), Verity *Jago* (World Premiere by Mike Westbrook). Opera on record includes: Flower girl/ Forest creature *The Poisoned Kiss* conducted by Richard Hickox for CHANDOS Records.

ELINOR JANE MORAN (MIMI)

Elinor studied at the Guildhall School of Music and Drama where she was awarded several scholarships and awards. Recent operatic roles include Rosina *The Barber of Seville* (OperaUpClose Tour), Anna *Don Giovanni* (OperaUpClose/Soho Theatre), Mrs Bear Crawford *Beginners* (Linbury Studio), Mimi *La Bohème* (OperaUpClose/Soho Theatre), Michaela *Carmen* (EPOC /Royal Albert Hall), Pamina *The Magic Flute*, Susanna *The Marriage of Figaro*, Rusalka/Voran *May Night*, Rowan *The Little Sweep*. Elinor has been the recipient of the Garsington Young Artist's Award. Oratorio performances include

Haydn *Creation,* Schumann *Requiem,* Rossini *Petite Messe Solenelle,* Verdi *Requiem* (Lighthouse Theatre Poole), Mozart *Requiem* (Cadogan Hall), Haydn *Nelson Mass,* Mozart *Coronation Mass,* Fauré *Requiem,* Mozart *Vespere Solonne De Confessore*, Rutter *Feel The Spirit*, *Magnificat,* Mendelssohn *Elijah*, Vivaldi *Gloria*. Other performance highlights include dancing in the Olympic Opening Ceremony and featuring as a soloist on a SONY BMG recording 'The Best Of Gilbert And Sullivan' a Classical Chart number one. Alongside her busy performance schedule Elinor is in demand as a vocal animateur and has worked for such companies as The Royal Opera House, English Touring Opera, Opera North and the Canadian Children's Opera Chorus in this capacity. Future work includes directing her first children's opera *Hedgehog's Home* (Conway Hall) and assisting on *Towards an Unknown Port* (ETO Linbury Studio and tour).

GARETH DAFYDD MORRIS (RODOLFO)

Gareth Dafydd Morris studied at the Royal Welsh College of Music and Drama and the Royal Academy of Music. Roles include Monsieur Triquet *Eugene Onegin* (Opera Holland Park), Borsa *Rigoletto*, 1st Servant *Capriccio* and Bardolfo *Falstaff* (all for Grange Park Opera), title role *Roberto Devereux* (Opera Valladolid), Alfred *Die Fledermaus* and Camille *The Merry Widow* (both for Opera

della Luna), Rodolfo *La Bohème* (OperaUpClose), Ernesto *Don Pasquale* (Candlelight Opera), Count Almaviva *The Barber of Seville* and Don Basilio & Don Curzio *The Marriage of Figaro* (Armonico Consort), Don Carlo *Don Carlo in Love* (Opera Minima), Hyllus *Hercules* (Swaledale Music Festival), Tamino *The Magic Flute*, Paris *The Ten Belles*, Mad Hatter *Alice in Wonderland* and Jason's Father *Jason and Hanna* (all RWCMD). In demand on the concert platform, Gareth performs throughout the UK and Europe all the major works, masses and requiems, most notably at St John's Smith Square, Cadogan Hall, Bridgewater Hall, Colston Hall, Brangwyn Hall, Rochester, Canterbury, Arundel, Guildford, Bristol, Exeter, Brecon, Llandaff and Carlisle Cathedrals. He has broadcast as a soloist with both the BBC National Orchestra of Wales and the BBC Philharmonic Orchestra on BBC Radio 2, 3 and 4.

MARTIN NELSON (ALCINDORO)

Martin has sung principal roles at the Royal Opera, many UK and European opera companies and festivals, and also performs in musicals, contemporary music and straight theatre. Operatic roles created: Dr. Kalmenius *Clockwork* (Stephen McNeff), Owl *Philoctetes* (Edward Rushton), Olivier *Thérèse Raquin* (Tobias Picker, all at ROH2), another Owl *Tarka the Otter* (McNeff), Tiresias *Burial at Thebes* (Globe Theatre), Seneca *Coronation of Poppea*

(Monteverdi/Ravenhill/Silverman for OperaUpClose). Other roles: Osmin *Il Seraglio*; Bartolo/ Antonio *Marriage of Figaro*; Don Alfonso *Così fan Tutte*; Sparafucile *Rigoletto*; Bottom & Quince *A Midsummer Night's Dream*; Hotel Manager *Powder her Face*. West End and musicals: *Phantom of the Opera*; *A Little Night Music*; title role *Sweeney Todd* (Pimlico Opera/Wormwood Scrubs Prison and National Theatre), Mysterious Man *Into the Woods* (Royal Opera), Dick Deadeye *HMS Pinafore* (D'Oyly Carte, Savoy Theatre/US tour). Recent work: Benoit/Alcindoro *La Bohème*, Commendatore *Don Giovanni* (Soho Theatre/OperaUpClose) and in the movie *Sherlock Holmes 2*; Basilio *Barber of Seville* (Opera Brava), Sarastro *Magic Flute* (Co-Opera Co), Voice One *Under Milk Wood*, the world premiere *Mittwoch aus Licht* Stockhausen (Birmingham Opera/Cultural Olympiad). An unusually diverse career includes recording, radio, TV, oratorio and voiceover engagements, as well as devising environmental projects (Scrap & Scratch Opera, EQ). eqaudit.com

ANTHONY PINNICK (CHORUS)

Anthony was involved in the chorus of *La Bohème* last year at the King's Head. Recent theatre credits include: Airman in *The Ones Who Kill Shooting Stars* (White Bear, Kennington), Queen Elizabeth, 1st Murderer, Tyrrel and other roles in *Richard III* (Festival Players UK tour), and Lucius and Cinna the Poet in *Julius Caesar* (Brockley Jack Studio Theatre).

He also appeared as the painter John Constable in *Her Fanciful Digression*, an art film exhibited earlier this year, as well as several short and student films. Anthony trained at Drama Studio London.

UNA REYNOLDS (MUSETTA)

Una read Psychology at Sydney University while studying Voice. Before relocating to the UK, Una was a member of the chorus of Opera Australia and performed in productions *The Mikado* and *Pirates of Penzance.* She also appeared as Josephine in *HMS Pinafore,* Princess Zara in *Utopia Limited* and Edith in *Pirates of Penzance* (Rockdale Opera). Since moving to the UK, Una has performed in *Queen of Spades* and *Eugene Onegin* with Grange Park Opera.

PRUDENCE SANDERS (MUSETTA)

Originating from Australia, Prudence Sanders commenced her UK training at the Guildhall School of Music and Drama under the tutelage of John Evans. In 2011, Prudence became an Associate Artist at the Associated Studios, working with David Gowland, Olivia Fuchs, Jonathan Cohen, Janice Chapman, Natalie Murray, Mandy Demetriou, Jonathan Hinden, Robin Newton, Rebecca Evans, Alessandro Talevi and James Conway. Concert performances have included Handel's *Messiah* with the Lund Kammerkor and Winchester Choral Society, Papagena *Die Zauberflote* (Cambridge Philharmonic Orchestra), *The Creation* (Bradford Choral Society), Poulenc's *Gloria* (Ripon Cathedral), *Alexander's Feast*, (Bedford Summer Festival), Rossini's *Petite Messe Solennelle* (Bradford Choral Society) and Cunegonde *Candide* (Cambridge Philharmonic). Prudence has sung Susanna *Le Nozze di Figaro* (Autonomous Productions), Paquette *Candide* (WAAPA) and the title role in Jaques Ibert's *Angelique*. Recent roles include Governess (cover) and Miss Jessel (cover) *The Turn of The Screw* (Opera Up Close) and Musetta *La Bohème* (Opera Bohemia). Prudence was contracted in 2012 as a soloist in the world premiere of Stockhausen's *Mittwoch Aus Licht* (Graham Vick, Birmingham Opera). Future engagements include Mahler *4th Symphony* (Cambridge Philharmonic), *Dona Nobis Pacem*, Vaughan Williams and *Magnificat*, Rutter (Watford Philharmonic), and further collaborations with London Voices for film soundtracks and at the Royal Albert Hall in November.

JAMES SCHOUTEN (CHORUS)

James is currently in his final year at Goldsmiths College studying Voice under Nan Christie. He has been involved in many classical and popular music ensembles. So far, the 20-year old baritone has sung in the following operas: Schaunard *La Bohème* (Opera Gold), Giorgio Germont *La Traviata* (Opera Gold) and The Officer *Il barbiere di siviglia* (Opera de Baugé). To mark

twenty years of the fall of the Soviet Union, James sang the role of the Speaker in Radvilovich's *Big Brother* as part of the *'Mother Russia: Evolution or Revolution Symposium'* held at Goldsmiths and the Barbican Centre. His choral roles include the following: *Dido & Aeneas*, Handel's *Messiah* (Amade Players), *Il barbiere di siviglia*, *Romeo et Juliette* and *Tosca* (Opera de Baugé). Outside of classical music, James has recently been part of such groups as the neo-romantic rock band *Shoot the Director*, K-pop band *Hugh Keice* and South-East London party band *Lab Rats,* amongst other student-led jazz and musical-theatre ensembles.

REBECCA SHANKS (CHORUS)

Rebecca Shanks trained at The Oxford School of Drama and works as an actress and singer. Recent work includes; Soprano soloist in *The London Requiem* (The Space/BBC), Spring/First Nereid in *Dido and Aeneas* (Teatro Cesare Caporali, Italy), Pamela in *The Cab Ride* (Abelle Films), Chorus Soloist in *Don Giovanni* (Soho Theatre), Lizzie Stride in *Ripper* (Wilton's Music Hall), Chorus Captain in *La Bohème* (Soho Theatre), Florinda in *The Rover* (Southwark Playhouse), Various in Ken Campbell's *School of Night* (Drill Hall), Young Woman in *Machinal* (Battersea Arts Centre), Hannah in *Shoot me!* (Brighter Pictures).

TOM STODDART (MARCELLO)

Young baritone Tom Stoddart has recently performed the role of Jack Rance *La Fanciulla Del West* for OperaUpClose to critical acclaim at The King's Head Theatre, Islington, Leporello in *Don Giovanni* (OperaUpClose) at the Soho Theatre and Paul in *Les Enfants Terribles* as part of the Grimeborn festival. His recent solo concert work includes; Mozart *Requiem*, *Nelson Mass* (Haydn), *Petit Messe Solennelle* (Rossini), Duruflè *Requiem*, *Carmina Burana* and *St John Passion*. Tom has recently created the role of Chandler in Comedy Central's *Friends – The Opera*. Tom studies with Robert Dean.

ALISTAIR SUTHERLAND (SCHAUNARD)

Alistair Sutherland regularly performs as a baritone in London, frequently performing Schaunard *La Bohème* for OperaUpClose. He sings with the chorus at Opera Holland Park, where he also performed Pinellino *Gianni Schicchi* as part of their 2012 Christine Collins young artist programme. He has recently completed an MA in vocal studies from The Royal Academy of Music under Alexander Ashworth, and works closely with director Julie Osman regularly performing for her company Freathy Tippet. On the recital platform Alistair is a true amateur of Tchaikovsky and is also keen to find and perform contemporary songs, recently performing 'A Dylan Thomas Song Cycle' by Peter Dickinson

at the Hackney WickED festival. His recent performances include Pinellino *Gianni Schicchi* (Opera Holland Park, Christine Collins young artist performance), *The Open Cage* by Danyal Dhondy, Dandini *Cinderella* (OperaUpClose), *Saul Salty Sarah* (Freathy Tippet), Baritone *Voicings* (Freathy Tippett), Colline *La Bohème* (OperaUpClose), Yamadori/ First Officer *Madama Butterfly* (OperaUpClose), Aeneas *Dido and Aeneas* (King's Opera).

ROBIN NORTON-HALE (DIRECTOR & LIBRETTIST)

Robin founded OperaUpClose alongside Adam Spreadbury-Maher and Ben Cooper in October 2009. Her directing credits for OperaUpClose, all in her own new English translations, are *La Bohème* (Soho, Cock Tavern & King's Head Theatres, winner of the 2011 Olivier Award for Best Opera and the Whatsonstage.com Award for Best Off-West End Production), *Don Giovanni* (Soho Theatre) and *The Barber of Seville (or Salisbury)* (King's Head Theatre and UK tour). Other directing credits include the world premiere of Glyn Maxwell's *Masters, Are You Mad?* (Grosvenor Park Open Air Theatre), *The Taming of the Shrew* (Southwark Playhouse), Martin Duberman's *Visions of Kerouac* (Half Moon Theatre), Glyn Maxwell's *Best Man Speech* (UK tour), *Pick 'n' Myths* (devised for Lyric Theatre Hammersmith and UK tour), *Spirit of Vienna* (English Touring Opera), *Live Canon* (Northcott and Greenwich Theatres), *Happy Campers* (site specific performances at Montagu Close), *Pimpinone* (Colourhouse Theatre), and a revival of James Conway's production of *Ariodante* for ETO. She was Associate Director on *Cloudcuckooland*, a new musical by Stephen Sharkey and Alex Silverman (UK and international tour), Assistant Director credits include *Sweet Charity* (Theatre Royal, Drury Lane), *Katya Kabanova* and *The Seraglio* (both ETO). For Christmas 2012 she directs her own new version of *Let's Make an Opera* and Britten's *The Little Sweep* for Malmö Opera House, Sweden, and a chamber version of *La Traviata* for Malmö Opera in 2013.

ELSPETH WILKES (MUSICAL DIRECTOR)

Born in Leigh-on-sea, Essex, Elspeth studied at King's College, London, Trinity College of Music and the Royal Academy of Music. She has performed at venues including St John's Smith Square, Linbury Studio, Royal Opera House, Soho Theatre, Swan Theatre, Stratford-upon-Avon, St James', Piccadilly and St Giles' Cathedral, Edinburgh and has worked with the Royal Ballet, Royal Shakespeare Company and Southbank Sinfonia amongst others. As musical director/chorus master/repetiteur, Elspeth has worked with companies including OperaUpClose (*Tosca, Carmen, Don Giovanni, The Coronation of Poppea, Madam Butterfly, Barber of Seville*), Tête à Tête Opera Festival (Stephen Crowe

ensemble), New Devon Opera (*Madame Butterfly*), Northern Ireland Opera, Longborough Festival Opera (*Midsummer Night's Dream*), Chelmsford Opera (*La Traviata, L'Elisir d'Amore, I Pagliacci*), English Touring Opera and Opera de Baugé (*Romeo and Juliette, The Magic Flute, Fidelio*) playing continuo on their productions of *Barber of Seville, Orfeo ed Euridice, La Finta Giardiniera* and *Giulio Cesare*. Elspeth was the accompanist for BBC Wales's *Lesley Garrett and Friends* and works as accompanist/ assistant conductor with Barnes Choir, London Oriana choir and Thurrock Choral Society. Elspeth is a member of the *Argento Trio* (soprano, clarinet, piano) who perform specially commissioned works alongside existing repertoire all over the UK.

EMILY LEATHER (ASSOCIATE MUSICAL DIRECTOR)

After graduating from the University of Leeds, the Guildhall School of Music and Drama and the prestigious College-Conservatory of Music in Cincinnati, Emily enjoys a varied career as a repetiteur, vocal coach and Music Director, as well as working as an arranging and composer. In the US Emily has been on staff with Cincinnati Opera (*Un Ballo in Maschera, L'Etoile, Tosca, Tales of Hoffmann*), Portland Opera (*Hansel and Gretel*), Kentucky Opera (*Turandot, Il Trovatore, Dialogues of the Carmelites, Samson et Dalila*) and Opera

Manhattan (*Hansel and Gretel, Dido and Aeneas*). Previous work in the UK includes productions for British Youth Opera (*Magic Flute, Semele*), Clonter Opera (*Die Fledermaus*), London Lyric Opera (*Fidelio*) and Glyndebourne Touring Opera (*Tangier Tattoo*). For OperaUpClose Emily was Music Director for *Don Giovanni* at the Soho Theatre and toured with *Barber of Seville* and *La Bohème*. Emily is on staff at the Royal Opera House as repetiteur for the Youth Opera Chorus. Passionate about opera education she regularly works for Opera North, Royal Opera House and English Pocket Opera. Her children's opera *Hedgehog's Home* will premiere at Conway Hall in Central London this November, a musical staging of a very popular Croatian children's story.

LUCY READ (DESIGNER)

Lucy Read is a London based set and costume designer. She trained under Alison Chitty on the Motley Theatre Design Course, 2008. In 2010 Lucy was short listed for both the Linbury Prize and the Jocelyn Herbert Award for exceptional stage design. Lucy has a diverse portfolio including designs for Opera, new writing and site specific performance. Her most recent work includes the promenade, site specific production of *9 Rooms* for the charity Center Point at the Old Vic Tunnels. Lucy works extensively with The Royal & Derngate Theatre, Northampton. Her designs include: *Carmen, Illyria, The Love*

of *The Nightingale*, *A Comedy Of Errors*, *Basset* and *Unheard*. Lucy has a long-standing relationship with The Oval House Theatre, London. Her work there includes; *The Grandfathers*, *Suffocation* and *Romeo & Juliet*. Earlier this year Lucy designed the Serbian Opera premiere of *Narcissus & Echo* for the Lowry Theatre, Manchester & UK tour and *Sleepy Hollow* for Watford Palace Theatre. Forthcoming work includes *His Dark Materials* and *Spring Awakening* for the Royal & Derngate Theatre.

KATE GUINNESS (DESIGNER – ORIGINAL PRODUCTION)

Kate Guinness is a freelance set and costume designer, trained on the Motley Theatre Design Course. She designed the original production of *La Bohème* at The Cock Tavern Theatre as well as its transfer to the Soho Theatre which won the Olivier Award 2011 for Best New Opera Production. Other opera design includes: *The Magic Flute*, *A Dinner Engagement*, *Gianni Schicchi*, *The Telephone*, *Trouble in Tahiti*, *La Serva Padrona*, *La Bohème* and *Winners* for Wexford Opera Festival ShortWorks 2010, 2011 and 2012. Theatre: *The York Realist* (Riverside Studios), *The Potting Shed* (Finborough), *Studies for a Portrait* (King's Head Theatre), *Shrunk* (The Cock Tavern Theatre), Nuffield Youth Theatre's production of *A Handbag* for NT New Connections (Chichester Festival Theatre). Musicals: *Sugar* for Pimlico Opera at HMP Send –

educational and rehabilitative collaboration with inmates. Kate designed and curated the exhibition Against Human Trafficking for The Houses of Parliament in February 2010. She is currently working at JR Design in London.

RICHARD WILLIAMSON (LIGHTING DESIGNER)

Lighting designs include: *The Last Session* (Tristan Bates Theatre), *Tosca* (OperaUpClose), *Vieux Carré*, *Denial*, *Someone To Blame* (King's Head Theatre), *The Dark Side Of Love* (Roundhouse), *Spinach* (the Edge Theatre and Arts Centre), *Happy New* and *The Firewatchers* (Old Red Lion), *20ᵗʰCentury Boy: The Musical* (New Wolsey Theatre), *The Execution of Justice* and *The Taming of the Shrew* (Southwark Playhouse), *The Provoked Wife* (Greenwich Playhouse), *Thrill Me* (Tristan Bates Theatre), *Amphibians* (Bridewell Theatre), *Richard III, An Arab Tragedy* (Swan Theatre Stratford and international tour), *Boy With a Suitcase, Peer Gynt, Macbeth, A Midsummer nights Dream, The Night Just Before the Forest, Tartuffe, Through a Cloud, King Arthur, Mojo Mickybo, The Great Theatre of the World, Tombstone Tales* and *The Country* (Arcola Theatre), *In My Name* (Trafalgar Studios), *Follow* (Finborough), *Play Size* (Young Vic), *Dutchman* (Etcetera Theatre & Edinburgh Festival), *Blue Jam* (Etcetera Theatre & Riverside Studios). As Associate LD – *Mrs Warren's Profession* (Strand Theatre

London & national tour) and as Assistant LD – *Elmina's Kitchen* (national tour & West End). Future productions include: *The Promise* (Arts Ed). Richard is Production Manager for C venues at the Edinburgh Festival and Technical Manager for the Greenwich and Docklands Festivals.

CHRISTOPHER NAIRNE (LIGHTING DESIGNER – ORIGINAL PRODUCTION)

Besides *La Bohème*, previous opera work includes: *For a Look or a Touch* (King's Head Theatre), *The Impresario* (Augustine's, Edinburgh), *Albert Herring* (Surrey Opera) and *The Cunning Little Vixen* (Ryedale Festival Opera). Recent theatre credits include: *Trauma* (White Bear Theatre), *The Busy Body*, *Someone Who'll Watch Over Me* and *The Belle's Stratagem* (Southwark Playhouse), *Celebrity Night at Café Red* (Trafalgar Studios), *The Vocal Orchestra* (Udderbelly, Southbank and Edinburgh), *Peer Gynt Recharged* (Riverside Studios), *Serious Money* (Pegasus Theatre, Oxford), *Shallow Slumber* (Soho Theatre), *Don Quixote* (Warehouse Theatre, Croydon) and *A Dish of Tea with Dr Johnson* (Out of Joint, UK tour & Arts Theatre). Cabaret work includes numerous shows for Frisky and Mannish (including Lyric Theatre, Edinburgh Fringe & UK/international tours), Shlomo (Southbank Centre & Edinburgh Fringe), Morgan & West (Edinburgh fringe) and various burlesque troupes (including at the O2). Further details, and a full list of credits, are available on his website: www.christophernairne.co.uk.

DOMINIC HADDOCK (PRODUCER)

Dominic graduated in Theatre & Performance Studies from the University of Warwick. He pursued a career in the city, cofounding a successful business development agency, before returning to the theatre. He has worked in various capacities for Really Useful Theatre; Headlong Theatre; Out of the Blue Productions; The Onassis Programme; Iris Theatre; and The Associated Studios. Recent producing credits include *Tosca* (OperaUpClose), *Vieux Carré* (King's Head Theatre & Charing Cross Theatre), *Carmen* (OperaUpClose), *Someone to Blame* (King's Head Theatre), *La Fanciulla del West* (OperaUp Close), *Constance* (King's Head Theatre), *Manifest Destiny* (OperaUpClose), *The Turn of the Screw* (OperaUpClose), *A Cavalier For Milady* (The Cock Tavern Theatre & The Jermyn Street Theatre), *I Never Get Dressed Till After Dark On Sundays* (The Cock Tavern Theatre), *Pagliacci* (OperaUpClose), *Madam Butterfly* (OperaUpClose), *The Barber of Seville* (OperaUpClose), *The Wind in the Willows* (Iris Theatre), *Romeo & Juliet* (Iris Theatre). Dominic is the Executive Director of OperaUpClose & the King's Head Theatre.

ADAM SPREADBURY-MAHER (PRODUCER)

Adam is an award-winning director and producer, originally trained as a tenor in Australia. Adam founded the Cock Tavern Theatre in 2009 and won The Peter Brook Dan Crawford award. He founded OperaUpClose with Ben Cooper and Robin Norton-Hale, producing *La Bohème* at the Cock Tavern and Soho Theatres, winner of the Olivier Award for Best Opera. Directing highlights: Louis Nowra's *Così* and Daniel Reitz's *Studies For A Portrait* (White Bear), Peter Gill's *The York Realist* and *The Sleepers Den* (Riverside Studios), Hannie Rayson's *Hotel Sorrento* and a new play by Edward Bond, *There Will Be More* (Cock Tavern Theatre), and in Australia Jonathan Harvey's *Beautiful Thing* and Joe Orton's *Loot*. For OperaUpClose he directed *Madam Butterfly* (King's Head). Producing highlights: Jack Hibberd's *A Stretch of the Imagination,* the hit musical *Pins and Needles,* and the landmark six-play Edward Bond retrospective (Cock Tavern Theatre), *The Coronation of Poppea* and *Someone to Blame* (King's Head) and *Don Giovanni* (Soho Theatre). In 2010 Adam became Artistic Director of the King's Head and won Best Artistic Director in the Fringe Report Awards. In 2011 he was nominated for Best Director in the Off-West End Awards and directed a new four singer version of *Tosca* for Malmö Opera and OperaUpClose over summer and autumn 2012. Follow him on twitter @Spreadbury

STEVEN LEVY (PRODUCER)

Steven Levy has spent the past 25 years as a theatrical producer, general manager and theatre owner in both New York and London. Credits on Broadway include: *Hot Feet* (Hilton Theatre), *Whoopi – The 20th Anniversary Show* (Lyceum Theatre; starring Whoopi Goldberg; Tony Award nomination), *Oldest Living Confederate Widow Tells All* (Longacre Theatre; starring Ellen Burstyn), *Our Town* (Booth Theatre; starring Paul Newman), *I'm Not Rappaport* (Booth Theatre), *Dame Edna: The Royal Tour* (Booth Theatre; Tony Award), *The Beauty Queen of Leenane* (Water Kerr Theatre; four Tony Awards), *The Lonesome West* (Lyceum Theatre; four Tony Award nominations), *Waiting in the Wings* (Walter Kerr Theatre; starring Lauren Bacall). West End: *6 Actors in Search of a Director*, *Fascinating Aïda – Cheap Flights*, John Leguizamo – *Ghetto Klown*, Patricia Routledge – *Facing The Music*, *Thrill Me* (all at the Charing Cross Theatre), *Singular Sensations* (Theatre Royal Haymarket), *Nixon's Nixon* (Comedy Theatre), Tom Stoppard's *The Invention of Love* (Theatre Royal Haymarket), *Gross Indecency* (Gielgud Theatre), *The Boys in the Band* (Aldwych Theatre). Off-Broadway: *Waiting for Godot* (Theatre at St. Clements; 50th Anniversary Production), *Kiki and Herb*

(Cherry Lane Theatre), *As Bees in Honey Drown* (Lucille Lortel Theatre; Drama Desk Award), *Gross Indecency* (Minetta Lane Theatre; Outer Critics Circles Award, Lucille Lortel Award), *Molly Sweeney* (Criterion Centre; starring Jason Robards and Alfred Molina), *The Syringa Tree* (Playhouse 91; Obie Award).

VAUGHAN WILLIAMS (PRODUCER)

After graduating in English Literature from London University, Vaughan Williams took a brief 33-year detour into the world of finance. He qualified as a Chartered Accountant with Deloitte and then enjoyed a long career at merchant bankers Morgan Grenfell & Co, whose Board he joined in 1993, then in Deutsche Bank's investment banking business, where he was a Managing Director. Vaughan's specialities included financial risk management, the planning and financing of complex projects and the financing of major physical assets such as passenger aircraft, oil tankers etc. He is also Chairman of TP12(1) VCT plc, a company recently floated on the London Stock Exchange to invest in Renewable Energy projects. Vaughan maintained his passionate interest and involvement in theatre and opera throughout, including a spell on the Board of the King's Head Theatre. He and his partner Stefanie Spencer (formerly the Performing Arts Librarian at The Drama Centre, London) attend around 150 theatre and opera shows a year. In early 2011 Vaughan was a founder of and major shareholder in the company that acquired the Charing Cross Theatre and now, following his retirement from the City 'while still young enough to enjoy a second career', he is repaying his debt to society by devoting the majority of his time to the theatre industry. His first production was the premiere of Steven Berkoff's *6 Actors in Search of a Director* and he is currently working on a number of further projects.

KILBURN OPERA HOUSE

I n a notorious Irish pub on Kilburn High Road, the bathroom still daubed with IRA slogans and inhabited by an army of hardened drinkers, a group of opera singers began rehearsing Act 2 of Puccini's *La Bohème*. It was 10am, and needless to say, the pub cleared pretty quickly, as the locals nursing their hangovers couldn't put up with the racket – apart from one man, who stood and shouted 'Get your knickers off' to Musetta for an entire hour. It was far from the grand Teatro Regio in Turin where *La Bohème* was first performed in 1896 – although not dissimilar to the shabby garret in Paris where the opera is set. 'La Bo' as it affectionately became known, was days away from opening at The Cock Tavern Theatre.

In October 2009, Adam Spreadbury-Maher, the artistic director of the Cock Tavern Theatre, said, in typical throwaway style: "I'd like to do an opera here at Christmas. I'd like it to be *La Bohème*. We'll probably need two or three casts, since they won't be able to sing the big roles more than twice in a row. And the opera singers should be in their twenties, like the characters are supposed to be. Oh, and we've got no money."

The first task was to find a director, musical director and potentially a librettist (we were committed to presenting the opera in English, but on such a timescale we weren't sure a brand new translation was even possible). I'd worked with Robin Norton-Hale on a musical and I knew she had an opera background and was a gifted director. She was up for it immediately. Adam had met Andrew Charity, an award-winning conductor and musical director, after a show. We called him up, he said yes straight away, and we had two thirds of our team. Now for a librettist. We were stuck – before Robin said she'd give it a try. And so the beginning of the jewel that is her stunning and critically-acclaimed libretto was born, with all of us tippexing over an out-of-copyright score we'd found so Robin could write her new translation on top. Over the next two weeks, Robin was up all night, every night (I know, because she spent much of it at my kitchen table) writing her libretto. We thought getting it done in time would be an impossible task. But she did it, and in style.

Meanwhile, in the production office at The Cock Tavern (a cramped pub kitchen) we were trying to cast the show and find free rehearsal space to save money in our tiny budget. In the end, before getting the support of Arch468 in Brixton, the first week of rehearsals took place in Robin's living room in Hackney, eight opera singers belting out arias to the bemusement of her neighbours and flatmates. We were ringing everyone we knew who could play the piano to see if they could help us out as repètiteurs, while Robin was dashing out of rehearsals to field calls from journalists who had heard about the project. First Louise Jury (the *Evening Standard*) ran a short piece, and then Stephen Moss from the *Guardian* came and spent the day with us, running a fantastic feature in their Film and Music section. A major piece in *The Sunday Times* from Robert Shore followed, and we suddenly found ourselves with the country's most revered opera critics booked in for press night, as well as Reuters and the BBC World Service wanting to cover it.

We sold out almost straight away. First we extended by a month. The entire month sold out within a few days. Before we knew it, a six week experiment had turned into a six month project. The company grew from two casts to five, our volunteer chorus grew and developed under the leadership of Larissa Hunter, our chorus captain, who performed in all 126 shows.

Over the six months, our little theatre saw a host of famous faces: the opera director Jonathan Miller (who would later become our first patron), former head of the ENO Nicholas Payne, the GoCompare tenor Wyn Hughes, actress Janet Suzman, the artistic director of the Young Vic, David Lan, writer and director Nicholas Wright, Theatre Royal Stratford East artistic director Kerry Michael, politician Sir Peter Viggers, comedian David Mitchell and Australian TV legend Mike Walsh. On our first press night we were delighted to receive John Copley as our guest, whose *La Bohème* has been playing at the Royal Opera House for decades.

One Sunday afternoon, an usher came over to say that someone from Soho Theatre was in the audience and wanted to chat about the show. We ended up watching Act Two with Mark Godfrey, Soho Theatre's executive director, who then talked to us about taking the opera from Kilburn to Soho, the first time

the Soho would have ever done an opera, and our venue's first ever transfer. The Soho Theatre production was a great success and the show went on to win an Olivier Award for Best New Opera, and a Whatsonstage.com Award for Best Off-West End production.

It's been a story full of unsung heroes: notably our original staff director, Antonia Alonzo, who with Robin managed to organise the schedules of five different casts; Andrew Charity, who as well as being musical director accompanied almost every performance; our many stage managers: Neusha Milanian, Jacob Mason-Dixon, Cat Buffrey and the long-serving Charlotte McBrearty and Eloise Akehurst, and our team of repètiteurs, particularly Elspeth Wilkes.

The show comes now to Charing Cross Theatre, three years since its first performance, having been back to Soho Theatre for a second time, as well as touring the UK. We think the show has become the UK's longest continuously running production of an opera, and the company we formed, OperaUpClose, has produced a number of other successful new versions of classic operas from its home at the King's Head Theatre.

Clare Presland, one of our Musettas, described to me how one particular night, a local clapped and cheered through the entire Second Act shouting in drunken admiration at the top of his voice: 'This is ffffeeee-eatre'. Which I think, all told, was my favourite review of all.

Ben Cooper, original producer, *La Bohème*

OPERAUPCLOSE

We founded OperaUpClose (along with producer Ben Cooper) in October 2009 for the experiment of producing *La Bohème* at the Cock Tavern Theatre in Kilburn, a 35-seat theatre above a very rough pub. We had no idea if anyone would come to see the show, or even whether opera singers would be prepared to work in such a gritty, fringe environment.

Ben tells the story of the production's runaway success in his programme essay, and of course it will always have a special place in our hearts, but OperaUpClose has become far more than *La Bohème*. In October 2010 we became the resident company at the King's Head Theatre, re-launching the venue as a small-scale off-West End alternative to London's two established opera houses and opening the season with our second production, *The Barber of Seville (or Salisbury)*. We have now produced ten new opera productions at the King's Head: *Barber*, *Madam Butterfly*, *Cinderella*, *Pagliacci*, *The Coronation of Poppea*, *The Turn of the Screw*, *Manifest Destiny*, *La Fanciulla del West*, *Carmen* and *Tosca* (a co-production with Malmö Opera in Sweden), all in new English versions – including, in *Poppea*'s case, a libretto by Mark Ravenhill, with a new aria by Michael Nyman.

We feel passionately about producing contemporary opera as well as new versions of the classics, so this autumn we launched Flourish, a competition to find a new chamber opera. We were overwhelmed by the quality and variety of the entries and at a showcase of the finalists' work in September chose not just a winner (*Two Caravans* by Guy Harries and Ace McCarron, which will get a full production at the King's Head in 2013) but a runner-up (Katarzyna Brochocka and Gabriela Zapolska's *Young Wife*), which we felt strongly also deserved to be produced. So far we have Arts Council funding for one production but not two – watch this space!

In 2013, as well as our Flourish winners we'll present new productions of *L'elisir d'amore* and our second co-production with Malmö Opera, *La Traviata*, at the King's Head (as well as two other operas it is too early to announce). We're proud to have been the first opera company to perform at Soho Theatre, initially with *La Bohème*, and last summer with our electronica-tinged production of *Don Giovanni*, and we're also building a touring reputation, with our productions visiting venues from the Bristol Tobacco Factory to the Coventry Belgrade to Bestival.

Writing all this down, we're not quite sure how we've managed to stay sane and solvent so far. Thank you so much for your support by buying a ticket for this evening's performance – we hope very much that you enjoy it. If you would like to support us further by becoming a Friend or Patron of OperaUpClose – thank you! There's information about how to do so over the page. But most importantly, have a great evening.

Robin Norton-Hale & Adam Spreadbury-Maher
Artistic Directors, OperaUpClose

OPERAUPCLOSE

Become a friend of OperaUpClose...

Like our work? Want to support us? We are a completely unfunded producing house and so rely on box office sales and kind donations from members of the public who share our artistic vision and believe in what we're doing.

If you would like to make a donation to OperaUpClose and help us to continue to produce high quality work, there are a number of ways to do so:

Become a Friend **£25 per year**
Receive our weekly *What's On* newsletter
Acknowledgment on our website

Key to the Stage Door **£150 per year**
Receive our regular friends & patrons newsletter
Acknowledgment on our website and in programmes
Invitations to patrons' events

Key to the Dressing Room **£500 per year**
Receive our regular friends & patrons newsletter
Acknowledgment on our website and in programmes
Invitations to patrons' events
Priority ticket booking

Key to the Opera House **£1,000 per year**
Receive our regular friends & patrons newsletter
Acknowledgment on our website and in programmes
Priority ticket booking
Invitations to patrons' events
Free programmes for OperaUpClose productions
Reserved seats at any performance

To discuss becoming a Friend
please contact Dominic Haddock on

friends@kingsheadtheatre.com or call 020 7226 8561

CÔTE OFFER

"Robust French flavours, cheery continental vibes and brilliant value for money"

GOOD FOOD GUIDE 2011

CÔTE
BRASSERIE

COMPLIMENTARY DRINK WHEN DINING AT CÔTE ISLINGTON GREEN

WEEKDAY LUNCH & PRE-THEATRE MENU
2 COURSES, £9.95
Monday - Friday, 12 - 7pm

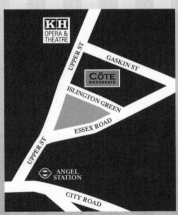

To enjoy a complimentary drink (house wine, house beer or soft drink) mention 'King's Head Theatre' to your waiter or when calling to make a reservation.

4-6 ISLINGTON GREEN, LONDON N1 2XA

T: 020 7354 4666 | E: islington@cote-restaurants.co.uk
www.cote-restaurants.co.uk

Valid with the a la carte menu (everyday) and the weekday lunch and pre-theatre menu (Monday to Friday 12-7pm). One complimentary glass of house wine, Meteor beer or soft drink per person ordering a main course.

COMING NEXT TO
CHARING CROSS THEATRE

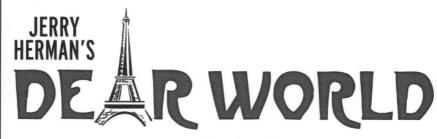

JERRY HERMAN'S

DEAR WORLD
a musical fable

Starring
BETTY BUCKLEY
and **PAUL NICHOLAS**

Directed and Choreographed by **GILLIAN LYNNE**

12 FEB – 30 MAR 2013
DEAR WORLD A MUSICAL FABLE

The British premiere of Jerry Herman's hit Broadway musical.

AT THE PLAYERS BAR AND KITCHEN...
we look to deliver the perfect balance of mouth watering food, great value and unpretentious friendly service. Our head chef has created a delicious menu to suit all tastes and appetites. The perfect place for pre theatre dining whether you are going to see a show in our own CHARING CROSS THEATRE or elsewhere in London's Theatreland district.

CHARING CROSS THEATRE
"Off Broadway in London"

Box Office: 0844 4930 650
charingcrosstheatre.co.uk
The Arches, Villiers Street, London, WC2N 6NL

VARLEY HAIR

346 UPPER STREET, ISLINGTON
LONDON N1 0PD
020 7226 0908

LA BOHÈME

Giacomo Puccini

LA BOHÈME

A new version by Robin Norton-Hale
after the Italian libretto by
Luigi Illica and Giuseppe Giacosa

OBERON BOOKS
LONDON

First published in 2010 by Oberon Books Ltd
521 Caledonian Road, London N7 9RH
Tel: +44 (0) 20 7607 3637 / Fax: +44 (0) 20 7607 3629
e-mail: info@oberonbooks.com
www.oberonbooks.com

Reprinted 2010 (twice), 2011, 2012

Version copyright © Robin Norton-Hale 2010

Robin Norton-Hale is hereby identified as author of this version in
accordance with section 77 of the Copyright, Designs and Patents Act
1988. The author has asserted her moral rights.

All rights whatsoever in this version are strictly reserved
and application for performance etc. should be made before
commencement of rehearsal to Micheline Steinberg Associates,
104 Great Portland Street, London W1W 6PE (info@steinplays.com).
No performance may be given unless a licence has been obtained,
and no alterations may be made in the title or the text of the play
without the author's prior written consent.

This book is sold subject to the condition that it shall not by way of
trade or otherwise be circulated without the publisher's consent in
any form of binding or cover or circulated electronically other than
that in which it is published and without a similar condition including
this condition being imposed on any subsequent purchaser.

A catalogue record for this book is available from the British Library.

ISBN: 978-1-84943-083-8

Cover photography by Pau Ros

Printed, bound and converted
by CPI Group (UK) Ltd, Croydon, CR0 4YY.

Visit www.oberonbooks.com to read more about all our books and
to buy them. You will also find features, author interviews and news
of any author events, and you can sign up for e-newsletters so that
you're always first to hear about our new releases.

Characters

RODOLFO
23, a writer

MARCELLO
23, an artist

COLLINE
24, a philosophy PhD student

SCHAUNARD
24, a musician

BENOIT
35, Rodolfo and Marcello's landlord

MIMI
27, a cleaner from Ukraine

MUSETTA
20, Marcello's on-off girlfriend

ALCINDORO
55, a corporate lawyer

DRINKERS, BAR STAFF, PIRATE DVD SELLERS,
CIGARETTE SELLERS

ACT I

Christmas Eve 2010. MARCELLO and RODOLFO's flat in Soho.

MARCELLO is painting and RODOLFO is gazing into space with his laptop on his knees.

MARCELLO: Why did I start this painting of the sea today? I feel as cold as if it were pouring over me. But in revenge, a sailor has to drown! What's up?

RODOLFO: I am admiring millions of windows steamed up all over the streets of Soho and thinking how that heater, that lazy ornamental radiator won't do a single thing to warm us up.

MARCELLO: Well it's been a whole fortnight since we last fed the meter.

RODOLFO: And although we are freezing there're better things to spend on.

MARCELLO: Rodolfo I must tell you a fascinating secret; it's bloody cold here.

RODOLFO: And I Marcello, I admit it, I would just love a moment of warmth now.

MARCELLO: And my fingers are ice blocks. It's as if I was still with Musetta. That woman has no feelings – she freezes me out completely.

RODOLFO: Yes, love is like a fire that burns out quickly…

MARCELLO: …but fiercely.

RODOLFO: Where the man is the tinder…

MARCELLO: …which the woman sets fire to.

RODOLFO: While he goes up in flames…

MARCELLO: …she laughs and finds another.

RODOLFO: But enough of that. I'm hungry.

MARCELLO: I think I've got pneumonia.

RODOLFO: We need a fire.

MARCELLO: Alright then, we'll burn something in the wastebin.

RODOLFO: I've got it.

MARCELLO: You've got what?

RODOLFO: Yes! Every great artist has had to sacrifice something.

MARCELLO: We'll burn my new painting?

RODOLFO: No. We would soon choke on the paint fumes. But my novel – its passionate sex scenes will fire us up.

MARCELLO: You're not going to read it. Please, spare me!

RODOLFO: No, the paper will crumble to ashes, the writing will go up in smoke clouds – from genius to a burnt offering. The loss will be tragic.

MARCELLO: So sad.

RODOLFO: Give me the first chapter.

MARCELLO: Here.

RODOLFO: Tear it!

MARCELLO: You light it…

RODOLFO: I told you I'm good.

MARCELLO: You've really got class.

COLLINE: *(Enters.)* What does the record exchange think it's playing at?! They say that nobody wants to buy the books that I take them. What are you doing?

RODOLFO: Quiet! There goes my novel.

MARCELLO: It's smoking.

COLLINE: It seems to be quite fiery.

RODOLFO: Brilliant!

COLLINE: And very short.

RODOLFO: Brevity is the soul of wit.

COLLINE: Great author I salute you.

MARCELLO: What happens next? I'm burning with excitement. Come on!

RODOLFO: Here is the next bit.

MARCELLO: *(To COLLINE.)* Don't interrupt it.

COLLINE: What steamy writing!

MARCELLO: So erotic!

RODOLFO: It's not just sex scenes I'll have you know, my beautifully structured plot's now been lost.

COLLINE: It shows great promise.

MARCELLO: There! Those were kisses.

RODOLFO: I'll burn the rest of it all at once.

COLLINE: So what's the verdict upon his novel?

RODOLFO, MARCELLO AND COLLINE: Masterful prose, we can't get enough.

MARCELLO: I don't think a lot of the ending.

COLLINE: I have to agree; disappointing.

MARCELLO: It's petering out into nothing…

MARCELLO AND COLLINE: It's his fault! We blame the author.

SCHAUNARD enters with a bag of food.

RODOLFO: A feast.

MARCELLO: Tequila.

COLLINE: Red wine.

RODOLFO: Chicken.

MARCELLO: Champagne.

RODOLFO, MARCELLO AND COLLINE: Well, it looks as if we'll celebrate this Christmas after all.

SCHAUNARD: You don't have to thank me I know you all adore me…

COLLINE: There's money here too!

MARCELLO: Hilarious Colline.

SCHAUNARD: Idiot! Look at this – you know this face?

RODOLFO: I bow to my sovereign and her jubilee.

RODOLFO, MARCELLO, COLLINE, SCHAUNARD: It's Her Majesty the Queen come to call upon us.

SCHAUNARD: Now you must hear, this food here, and yes, the money, has quite a tale behind it.

MARCELLO: Someone pass me the corkscrew.

COLLINE: And a glass while you're at it.

SCHAUNARD: An American actor – he's someone you'd recognise – required a musician…

MARCELLO: Make room, let's get started immediately.

RODOLFO: Where is the food?

SCHAUNARD: He calls me…

COLLINE: Catch!

MARCELLO: Here!

SCHAUNARD: I go around there. Of course he lives in Mayfair.

COLLINE: Excellent red wine.

MARCELLO: Fantastic vintage.

SCHAUNARD: I ask him who I'm playing for. I go around there, I visit him at his mansion, "Who do you want me to play for?" He answers, "This damn bird!" "I'll explain," he says and points to a parrot in a cage. Then he laughs, "You just keep on playing 'til he collapses!"

RODOLFO: Let's have romantic lighting for Christmas Eve!

SCHAUNARD: So I began, I played for three whole days…

MARCELLO: Here are the candles.

COLLINE: Pour me some wine then.

SCHAUNARD: But then I started to flirt with the actor's teenage daughter, the actor's teenage daughter, persuaded her to help me.

MARCELLO: No table cloth to eat off?

RODOLFO: Here you are.

MARCELLO AND COLLINE: We'll use the Guardian.

RODOLFO: We're multi-tasking; we'll eat while we digest the latest headlines.

SCHAUNARD: We fed the bird some sleeping pills. Yes, I'm afraid we drugged him. The parrot made it easy, he opened up his beak, he gobbled up his medicine and like Monroe he died. You haven't heard a single word, you bastards! What are you doing? No! Don't eat it now or there'll be none left for later. We'll need a feast for Christmas day tomorrow. On Christmas Eve it's a waste to stay home drinking. Think of the entertainment on our doorstep; so many things to make your tastebuds tingle! When all the spices of the curries float on the breezes through the alleys. And in the bars the prettiest things are waiting...

RODOLFO, MARCELLO AND COLLINE: Yes, and drinking through the night.

SCHAUNARD: And not all are faithful to their boyfriends! Come on, don't waste the evening or I'll disown you. Alright, one drink here. Then we're going out.

BENOIT: *(Offstage.)* Excuse me!

MARCELLO: Who is that?

BENOIT: Benoit.

MARCELLO: Bloody hell, it's the landlord!

SCHAUNARD: Lock the door quickly.

COLLINE: Nobody's here!

SCHAUNARD: We're out!

BENOIT: Just a word, please.

SCHAUNARD: One word.

BENOIT: *(Enters.)* Rent!

MARCELLO: Hello, why don't you join us?

RODOLFO: Of course.

BENOIT: Please don't bother, I only…

SCHAUNARD: Come on.

MARCELLO: A drink?

RODOLFO: Some lemon.

COLLINE: And salt too.

BENOIT: Thank you.

SCHAUNARD: Again.

RODOLFO: To you!

BENOIT: I have come here to remind you…

MARCELLO: Yes, I know!

BENOIT: And therefore…

SCHAUNARD: Let's have another.

BENOIT: Thank you.

RODOLFO: A toast!

MARCELLO: To you!

RODOLFO, MARCELLO, COLLINE AND SCHAUNARD: Here's to Christmas drinking!

BENOIT: I came because when you didn't pay your rent last month, you did promise…

MARCELLO: I promised and I'll pay it.

RODOLFO: What's this?

SCHAUNARD: He's mad.

MARCELLO: You see this? *(Showing him a note.)* And now stay just a minute and have another drink. Tell us about your girlfriend, dearest landlord Benoit.

BENOIT: My girlfriend! For God's sake.

RODOLFO: I thought you had a wife.

BENOIT: Stop it, leave me alone.

COLLINE: *(To RODOLFO.)* Marcello has a plan.

MARCELLO: Sunday evening, at a certain wine bar, you were seen with a girl.

BENOIT: Who?

MARCELLO: I was there; don't pretend you're not guilty. Admit it!

BENOIT: It's true but...

MARCELLO: Gorgeous woman.

BENOIT: Yes, very.

SCHAUNARD: Good work.

RODOLFO: She's pretty?

COLLINE: He's a dark horse.

SCHAUNARD: Seducer!

RODOLFO: Seducer!

MARCELLO: You should see her. What a woman!

RODOLFO: He's got good taste.

BENOIT: Ha ha.

SCHAUNARD: Good work.

MARCELLO: A body you would die for! She was all over him right there in public.

BENOIT: I'm good with the ladies.

RODOLFO, SCHAUNARD AND COLLINE: She couldn't keep her hands off him even in public.

MARCELLO: And he was loving every moment.

BENOIT: I was a nervous boy but now I am getting even. I've a full-fat weakness for full-fat women. You see, not that I

like them chubby or at all flabby, I like them well-built
with more than a handful. But skinny, mean and skinny,
no thank you! When they are skinny they are ungrateful
with nothing to hold on to. I can't stand their trouble and
strife, least of all from my wife.

MARCELLO: This man is married and has a bit on the side.

SCHAUNARD AND COLLINE: Disgrace.

RODOLFO: This man disgusts me; he is a corrupter of youth.

SCHAUNARD AND COLLINE: Out!

MARCELLO: We need to get him out of the house.

COLLINE: Throw the pervert out the house!

SCHAUNARD: Disgraceful behaviour.

BENOIT: But I…

MARCELLO: Disgusting!

BENOIT: I thought…

COLLINE: Disgraceful!

SCHAUNARD: You disgust us.

RODOLFO: Old pervert!

BENOIT: But I didn't…

COLLINE, MARCELLO, RODOLFO AND SCHAUNARD: Get out,
you disgust us! Just get out!

BENOIT exits.

RODOLFO, MARCELLO, SCHAUNARD AND COLLINE: And tell
your girlfriend that we all say, "Hello!"

MARCELLO: You can have your rent next year!

SCHAUNARD: Now it's time to be off for a night on the town!

MARCELLO: To drink our money.

SCHAUNARD: I'll lend you some cash.

RODOLFO: I'll have some.

COLLINE: Give it here.

MARCELLO: *(To COLLINE.)* There are always girls there – beautiful men too – don't let the side down, do us all a favour. Walrus! Get yourself a razor.

COLLINE: This moustache gives me gravitas with my students – useful when I lecture. I'll neaten it tomorrow before I go to my mum's house. Come on.

SCHAUNARD, MARCELLO, COLLINE: Let's go.

RODOLFO: I'm staying; I have to write a thousand more words for that new website.

MARCELLO: Then hurry.

RODOLFO: I will be with you in no time at all.

COLLINE: We'll wait for you in the bar down the road.

MARCELLO: If you are late we'll call you.

RODOLFO: Alright I'll be there.

SCHAUNARD: Better knock out your stupid thousand words. *(They exit.)*

MARCELLO: *(Offstage.)* Watch where you're going. Hold onto the railing.

RODOLFO: Be careful!

COLLINE: *(Offstage.)* The bulb's always broken.

SCHAUNARD: *(Offstage.)* Please don't let me break my neck.

Crash from offstage.

COLLINE: *(Offstage.)* Now I've done it!

RODOLFO: Colline, you dead?

COLLINE: *(Offstage.)* No, not quite.

MARCELLO: *(Offstage.)* We'll be waiting.

Lights go out.

RODOLFO: There goes the meter.

MIMI: *(Offstage.)* Hello.

RODOLFO: Who's that? Who can that be?

MIMI: *(Entering.)* Excuse me. I've run out of change for the meter

RODOLFO: Hello.

MIMI: I'm sorry…

RODOLFO: Come in while I look for some.

MIMI: I'm a nuisance.

RODOLFO: Not at all, come in.

MIMI coughs.

You're feeling ill?

MIMI: No, I'm fine.

RODOLFO: You're very pale though.

MIMI: I'm alright, I'm just tired…

MIMI faints.

RODOLFO: What am I meant to do now? I know! *(Splashes her with water.)*. She's a very pretty girl though. Do you feel better?

MIMI: Yes.

RODOLFO: It is very cold here. Why don't you put my coat on? Wait a sec, a glass of wine?

MIMI: Thank you.

RODOLFO: To you.

MIMI: Not too much please.

RODOLFO: Enough?

MIMI: Thank you.

RODOLFO: She really is gorgeous.

MIMI: I'm feeling better I really should go now. Thank you for helping…

RODOLFO: Such a hurry?

MIMI: Yes. Thank you, and good evening.

RODOLFO: You are welcome.

MIMI: Oh! How stupid, I cannot find my door key, how can I have lost it?

RODOLFO: Don't stand there in the doorway; the wind will blow out the candles.

RODOLFO blows out the candles without MIMI seeing.

MIMI: Yes, you are right. I'll come back in again.

RODOLFO: Oh no, they've gone out already.

MIMI: Ah! Now we'll never find my key.

RODOLFO: Please don't worry.

MIMI: What a nuisance.

RODOLFO: We'll find it soon.

MIMI: I'm so sorry I'm causing you such trouble.

RODOLFO: Really it's no trouble.

MIMI: I'm causing you such trouble.

RODOLFO: It's no bother, please don't worry.

MIMI: Look for it!

RODOLFO: I'm looking.

MIMI: Where can it be?

RODOLFO finds and pockets the key.

Did you find it?

RODOLFO: No!

MIMI: I thought you…

RODOLFO: No, honestly.

MIMI: Look then!

RODOLFO gazes at MIMI.

RODOLFO: I'm looking.

RODOLFO takes MIMI's hand.

Your fingers are half-frozen, let me warm them in my own. Don't bother searching; it's far too dark to find it. And when my friends come back we'll get the lights on and then we'll find your key without any trouble. And as you're my neighbour we should get to know each other. Shall I tell you what I do and what my dreams are? Shall I?

I am…Well who? I am a writer. What am I doing? Writing. How do I live then? Somehow! I don't make any money; money is overrated! I am writing a novel, perhaps it will be published and then when people read it, I'll share my world with them. And now you've come and stolen every impulse to work, when all I want to do is watch you. How could I sit here writing, knowing that you're so near me? You have ruined my chances of doing my work tonight! But I don't care about that. Real life is so much more exciting than what I'm writing.

So I've told you too much now. I hope I've not bored you. It is your turn to speak now – at least tell me your name.

MIMI: Well, I'm always called Mimi, but my name is Lucia. I don't have much to tell you. I just clean houses for wealthy people. I send home some money, but what I love is to make these flowers. There's something in these flowers, as I sew they enchant me! They make me think of home, of home in spring time. I put my dreams and memories in these flowers, when I'm lonely I sew them and I'm happy. You understand me?

RODOLFO: Yes.

MIMI: I'm always called Mimi, but I don't know why. Doing my work the daytime passes quickly, I stay home in the evening, but I don't really mind – though I live by myself. There from the window of my attic the snow on the rooftops is lovely. But when the snow is melting, the spring's first sun belongs to me, to me! The spring's first sunshine is mine. When cherry trees are starting to blossom then I watch petals falling. The air is full of the

scent of flowers. But those I make myself, my little cloth flowers, of course, they smell of nothing.

Now I've bored you far too long with my life. The nonsense I think all alone upstairs is hardly the most exciting…

SCHAUNARD: *(Off stage.)* Hey Rodolfo!

COLLINE: *(Off stage.)* Rodolfo.

MARCELLO: *(Off stage.)* Hello! Can you hear us? We're waiting!

COLLINE: *(Off stage.)* Why the hold up?

SCHAUNARD: *(Off stage.)* Do it tomorrow!

RODOLFO: Three more lines and I'll be ready.

MIMI: Who's that?

RODOLFO: My friends.

SCHAUNARD: *(Off stage.)* We won't wait forever.

MARCELLO: *(Off stage.)* Aren't you feeling lonely?

RODOLFO: I'm not lonely. Someone's with me. Why don't you go ahead and grab a table? I will join you later.

MARCELLO, COLLINE, SCHAUNARD: *(Off stage.)* Off to the bar with us — we understand now, you need to be alone.

SCHAUNARD, COLLINE: *(Off stage.)* Off to the bar.

MARCELLO: *(Off stage.)* The writer is inspired!

RODOLFO: Oh Mimi, you're so lovely, and you're my neighbour. I can't believe we've never met before. And all you've told me, it's only made you more beautiful to me.

MIMI AND RODOLFO: How could I have guessed it…

RODOLFO: …that you'd be so lovely…

MIMI: …that you would charm me completely.

RODOLFO: Come here and kiss me, Mimi, my darling. Now I've finally met you, say you are mine alone.

MIMI: Every word you say is drawing me more close towards you. I can't resist anymore.

They kiss.

No, stop it.

RODOLFO: My darling.

MIMI: Your friends are waiting.

RODOLFO: You're sending me away then?

MIMI: I'd like to…but I can't ask… Would you take me with you?

RODOLFO: What Mimi? Would you rather not stay at home with me? It's nice and warm here…

MIMI: I'll be warm beside you.

RODOLFO: And later?

MIMI: A mystery!

RODOLFO: Let's go my little darling.

MIMI: I'm yours to command.

RODOLFO: Are you with me?

MIMI: I'm all yours.

MIMI and RODOLFO exit.

MIMI AND RODOLFO: *(Offstage.)* All yours.

ACT II

Christmas Eve 2010. A bar in Soho.

PIRATE DVD SELLERS: I've all the latest releases, I've all the latest releases right here, right here!

DRINKERS: Cheers!

CIGARETTE SELLERS: Come get your cheap cigarettes, all the top brands, come get your cheap cigarettes then.

DRINKERS: Happy Christmas. Two days off. Cheers.

COLLINE: *(Enters with SCHAUNARD and MARCELLO. To a DVD SELLER.)* No, I've seen that one; do you have Skyfall?

MARCELLO: Just as I told you, lots of pretty girls. Come on Schaunard, I need you, back me up. I'll take the blonde one, you go and entertain her friends.

BARMAID: Those boys are here. Look here they come.

DRINKERS: Down it. Bottoms up.

MARCELLO: Hi girls, can I buy anyone a drink?

COLLINE: There's a table up there in the corner.

SCHAUNARD: Why don't you grab it? Save it for us. I'll get the drinks in.

MARCELLO: That's great then I'll have a pint of lager. Thank you.

SCHAUNARD: You're welcome.

RODOLFO: *(Enters with MIMI, who is carrying a bag from a nearby clothes shop.)* You're flirting.

MIMI: Are you jealous?

RODOLFO: How can I help it next to such a beauty?

MIMI: So I'm beautiful?

RODOLFO: Yes, you're gorgeous! And me?

MIMI: Yes, gorgeous!

DRINKERS: Let's have one more! Down it! Down it!

MARCELLO, COLLINE, SCHAUNARD: Cheers!

BARMAID: We've got some excellent drink offers on.

RODOLFO: Make room!

COLLINE: You took your time.

RODOLFO: Well, we're here now. This is Mimi. She is our
neighbour. And now she's here our evening reaches
another level. You see, I thought I was a writer but she is
much more eloquent. I told her all of my ambitions and
when she told me all of her dreams, her thoughts were so
intriguing… Don't you dare laugh, don't you dare laugh!

MARCELLO, COLLINE AND SCHAUNARD laugh.

MARCELLO: So it's her thoughts you like, then?

COLLINE: What a shameless charmer!

SCHAUNARD: I see what he means though.

COLLINE: Schaunard, she's with Rodolfo!

BARMAID: Any of you guys want something to drink?

COLLINE: A pint please.

SCHAUNARD: I'll have one too.

MARCELLO: And one for me.

SCHAUNARD: And some shots too.

COLLINE: Yes, bring five of them.

SCHAUNARD: Vodka or more tequila?

RODOLFO: They're not always like this.

MIMI: But they're nice.

SCHAUNARD: Bring some wine too, for the lady!

MARCELLO: Do you mind if I ask what expensive present my
generous friend has bought you?

MIMI: We bought this lovely little hat, I've wanted it for ages.
It's really pretty and I think it suits me. I always stopped

and gazed at it each time I passed the window. He knew I wanted it without my saying. Rodolfo knows exactly what I want, he understands me. He's something special.

MARCELLO: Alright then, if you say so.

COLLINE: He's practiced for romance by writing countless love scenes.

SCHAUNARD: Now they will ring more true with some experience.

MARCELLO: Deluded state of dreams and admiration. They see each other as complete perfection.

RODOLFO: *(To MIMI.)* By far my most attractive inspiration... to be with you is everything I need.

MIMI: *(To RODOLFO.)* To be together is the most delicious way to spend time.

MARCELLO: *(Overhearing MIMI.)* For some it's delicious. For others it's poison!

MIMI: Oh no, I upset him.

RODOLFO: It's not your fault Mimi.

SCHAUNARD AND COLLINE: It's time to toast.

MARCELLO: Fill up my glass.

RODOLFO, MIMI AND MARCELLO: To spending Christmas Eve among our friends...

RODOLFO, MIMI, MARCELLO, COLLINE AND SCHAUNARD: To friends!

MUSETTA and ALCINDORO enter.

MARCELLO: Bring me a shot of poison!

RODOLFO, SCHAUNARD AND COLLINE: Oh.

MARCELLO: She's here...

RODOLFO, SCHAUNARD AND COLLINE: Musetta!

DRINKERS AND SELLERS: Look! What? There! Where? Her – Musetta. Loud as ever. What an outfit!

ALCINDORO: Just like a servant, carrying bags all day. No! I've had enough.

MUSETTA: Heel Alchie, heel Alchie.

ALCINDORO: It's too much for me.

SCHAUNARD: This will be fun for us all to watch.

ALCINDORO: Not here! We'll be seen here. No!

MUSETTA: Stop it Alchie.

ALCINDORO: Please refrain from all your pet names when other people are listening.

MUSETTA: Don't speak to me like that.

COLLINE: His girls are getting younger.

MARCELLO: But she's hardly an angel.

MIMI: She does look lovely.

RODOLFO: Nothing compared to you though.

MIMI: Do you know who she is?

MARCELLO: Let me answer that. Her real name is Musetta...

MUSETTA: Marcello has seen me, but he's not looking. I'll show him!

MARCELLO: ...she should be called Temptation, a flirt and a prick-tease, she's not happy with one man, no, she changes her mind more often than her knickers.

MUSETTA: And Schaunard is laughing. But Marcello ignores me!

MARCELLO: She has to have attention...

MUSETTA: I will punch that smug face, wipe the smile from his mouth.

MARCELLO: ...it doesn't matter who from, just as long as they're loaded. Disgusting!

MUSETTA: But I can't do a thing while I'm here with this revolting old fool.

MARCELLO: Of course she'll leave him…

MUSETTA: Just watch me!

MARCELLO: …then he'll know how it feels. I need another drink!

MUSETTA: Hey, waiter here! Hey, waiter here! This glass is dirty, it smells disgusting.

ALCINDORO: No, Musetta. Quiet, quiet!

MUSETTA: He's not looking.

ALCINDORO: Quiet, quiet, please don't make a scene here.

MUSETTA: Ah, he's not looking.

ALCINDORO: Who's not looking?

COLLINE: *(Shouting to MARCELLO at the bar.)* Hey Marcello, some peanuts!

MUSETTA: Trust me I swear I will punch him.

ALCINDORO: What's the matter?

SCHAUNARD: My beer's already finished.

MUSETTA: This stupid waiter. Get off me! I'll do exactly what I feel like.

ALCINDORO: Please don't shout.

MUSETTA: I won't take any orders.

ALCINDORO: Please don't shout.

MUSETTA: Especially not from some old man.

DRINKERS: What's she doing with that old man? He must have lots of money! She knows how to spend it!

DVD SELLERS: I could take her off his hands. I reckon she would suit me.

DRINKERS, SELLERS: I don't see it lasting long.

MUSETTA: Could he be jealous of this old pervert?

ALCINDORO: My reputation! My family! Please don't shout.

MUSETTA: I wonder if he can hold out against the sight of me for very long?

SCHAUNARD: This is so entertaining.

MUSETTA: You still ignore me.

ALCINDORO: Can't you see I'm ordering?

SCHAUNARD: This is so entertaining.

COLLINE: Hilarious.

RODOLFO: You should know now that if you treated me like that I never would forgive you.

SCHAUNARD: She speaks to him but really to Marcello.

MIMI: But darling, why would I need to be so cruel? Please don't talk about forgiving.

COLLINE: And Marcello pretends… but we all know he's only ears for her.

MUSETTA: You know I make your blood flow.

ALCINDORO: Quiet, quiet.

MUSETTA: You know I make your blood flow.

ALCINDORO: Quiet, quiet!

MUSETTA: As I walk by, as I stroll along Regent Street, all the men stop and stare at me. Seeing my stunning figure, they can't tear their eyes away and they all want me for themselves.

MARCELLO: Will one of you please hold me back!

ALCINDORO: Please stop causing such a scene.

MUSETTA: I choose my outfits extremely carefully, but let me tell you a secret – they're dreaming as they see me in my best clothes, how I'd look with them off. And when I see what they are thinking I cannot help it. I tease them, they love it. I tease them, they love it!

ALCINDORO: Musetta please stop this, I'm really embarrassed.

MUSETTA: You who remember what it's like to be with me surely cannot resist me.

MIMI: To me it's clear, the beautiful Musetta adores this man we're with. It's all for him, this big display, the whole thing is for him.

MUSETTA: I know you're trying hard not to give in, but you know it's no good, you adore me again.

ALCINDORO: What will all these people think?

RODOLFO: They were together once but she's ambitious to a fault, wanted someone more important…

SCHAUNARD: Ah, Marcello will give in!

COLLINE: Any moment now he will!

SCHAUNARD: They're both as bad as each other. We have seen it all before.

COLLINE: I'm so glad I don't like women. Men don't cause all of this stress!

MUSETTA: Ah! Marcello loves me, Marcello can't resist me.

ALCINDORO: Not so loud! Quiet, quiet!

MIMI: She is unhappy; I hope he goes to her.

COLLINE: I suppose she's very pretty… but all this hassle, I just can't see how she is worth it.

MIMI: Darling!

RODOLFO: Mimi!

SCHAUNARD: Any moment now Marcello will give in.

RODOLFO: If I was him I'd never go back, I'd never trust her.

MIMI: But she adores him, the whole thing is for him. It's clear to me the whole thing is for him.

SCHAUNARD: It's just so entertaining.

MUSETTA: I know you can't admit it but I know you want me. Ah, you adore me again. *(To ALCINDORO.)* I'll do exactly

what I feel like, I'll do exactly what I like… take your hands off me, get off me!

ALCINDORO: Stop this shouting! Quiet, quiet…

SCHAUNARD: Marcello will give in.

COLLINE: I'm well out of it.

SCHAUNARD: I think you'd be just as bad, if some fit guy wanted you. I can't see you saying "no thanks" if a fit guy wanted you!

COLLINE: I suppose she's very pretty, but all of this fuss? I'm just glad I don't like women!

MUSETTA: Now it's time to get rid of this old man *(She screams.)* Aaaaah!

ALCINDORO: What now?

MUSETTA: Oh, it's hurting, it's so painful.

ALCINDORO: What's wrong?

MUSETTA: My foot. Take the straps off… rip the buckle! They don't fit me!

MARCELLO: I can't resist her.

MUSETTA: Just outside there's a shoe shop, hurry, quickly and get another pair.

ALCINDORO: Please stop shouting!

MARCELLO: I thought I had forgotten her, but I am still obsessed by her.

MUSETTA: It pinches, I can't bear it any longer. I hate cheap shoes; so take it from me then. Hurry! Go quickly… Go away… Go!

ALCINDORO: What will all these people think? Such a drama. Everyone is watching. Alright then. I'm going. No! *(Exits.)*

SCHAUNARD AND COLLINE: This is such great entertainment.

MARCELLO: *(To MUSETTA.)* It doesn't matter that you hurt me I will always want you to be mine.

MIMI: It's clear to me that Musetta wants Marcello!

RODOLFO: It's clear to me that she still wants Marcello.

MUSETTA: Marcello!

MARCELLO: Musetta! *(They kiss.)*

SCHAUNARD: Now we've reached the finale.

The BARMAID puts the bill on the table.

RODOLFO, SCHAUNARD AND COLLINE: The bill.

SCHAUNARD: Not already?

COLLINE: Did someone ask for it?

SCHAUNARD: Let's see.

RODOLFO: Pricey.

RODOLFO, SCHAUNARD AND COLLINE: All of you pay up.

SCHAUNARD: Colline, Rodolfo and oh, you…

MARCELLO: I don't have any.

SCHAUNARD: Really?

RODOLFO: I'm just as broke as usual.

MARCELLO, SCHAUNARD AND COLLINE: Really? Nothing at all?

SCHAUNARD: I'm sure I'd more than that.

DRINKERS: We should make a move it's late… Yes, drink up.

MUSETTA: *(To BARMAID.)* Give me my bill right away. Thank you *(Gives both bills to the BARMAID.)* Take the two bills and add them together – and the man who came with me will pay.

RODOLFO, MARCELLO, SCHAUNARD AND COLLINE: Yes he will pay.

MARCELLO: He will pay.

MUSETTA: And here where we were sitting he'll find a kiss goodbye.

RODOLFO, MARCELLO, SCHAUNARD AND COLLINE: And here where they were sitting he'll find a kiss goodbye. Here's to Musetta, we'll drink to you. Toast of the town. Not just a pretty face, she's clever too!

DRINKERS AND SELLERS: Let's stay for another, we've got two days off! Yes, let's stay for another, we've got two days off – it's Christmas Eve!

ACT III

November 2011. Outside a pub where MARCELLO and MUSETTA are living and working. MARCELLO is painting.

MIMI enters.

MARCELLO: Mimi!

MIMI: I hoped that I'd find you here.

MARCELLO: We've been here for a month. It's great as we're living rent free. Musetta sings her songs and the customers tip her, and I've been earning money painting these billboards. It's freezing, come in now.

MIMI: Is Rodolfo there?

MARCELLO: Yes.

MIMI: Then I cannot go in.

MARCELLO: Why not?

MIMI: Oh please Marcello, help me! Please help me.

MARCELLO: Mimi, what's happened?

MIMI: Rodolfo... Rodolfo loves me, but seems to hate me as much, he is madly jealous and says that he cannot trust me. A chance encounter, a smile, a word, arouses his suspicion and then he starts to hate me. At night when I pretend that I am sleeping, he lies beside me fuming, inventing ways I've hurt him. So many times he's told me: "I'm done with you. How can you love me Mimi? I'm done with you." Oh, I can't do this! It's jealousy that drives him, I know, but I can't live like this Marcello.

MARCELLO: If you're both so unhappy, then you should not be together.

MIMI: You are right, I should leave him, I have to admit it. But I need your help, I can't do it alone. We've broken up so many times but always go back.

MARCELLO: I'm laid back with Musetta just as she is with me so now we never disagree, we have fun and that's how our relationship works.

MIMI: You are right, but it's so hard when I still love him. But I know I should leave him.

MARCELLO: Alright, alright! I'll go and wake him.

MIMI: Wake him?

MARCELLO: He arrived here at 4 o'clock this morning and he's sleeping on the sofa. I'll show you. *(Mimi coughs.)* You are ill!

MIMI: I'm just so tired, Marcello. Last night Rodolfo left me and said to me, "It's all over." I knew he'd come to find you and I hoped that you could help us.

MARCELLO: *(Looking through window into interior of the pub.)* He's waking. He's found the tea I left him. He's coming.

MIMI: Don't let him see me!

MARCELLO: It would be better Mimi, if you went home. Don't make a scene out here.

MIMI exits.

RODOLFO: Marcello, can we talk now? I've got to tell you. I can't keep up this business with Mimi!

MARCELLO: Because there's someone else?

RODOLFO: So many times I have told her that we are through, but when I think of her with someone else, I cannot do it. Now it's really the end.

MIMI hides close by, out of sight of RODOLFO and MARCELLO.

MARCELLO: And you're going to stick to it this time?

RODOLFO: Yes, really.

MARCELLO: This is rubbish. You think too much, Rodolfo, why make it all so serious? If you just had fun together you soon would solve your problems. I think you're jealous.

RODOLFO: A little.

MARCELLO: It drives you mad, you know it's true, you're obsessive and cannot trust her; suspicious, aggressive.

MIMI: This will just make him worse. He gets so angry.

RODOLFO: Mimi is hardly perfect; always flirting with other men and then she'll tell me, "It's nothing," when they've got their hands all over her! And that's before we get started on her exes who she can't seem to get enough of.

MARCELLO: Rodolfo, please, you know this is crap.

RODOLFO: Alright then, yes, yes you're right. I know that Mimi loves me, but I'm scared that I'll lose her. I love her still. I'd stay with her forever, believe me. But it's no good now, I have to leave her. You heard how badly she's coughing? It gets worse every day now and I am scared that she will not recover.

MARCELLO: What's this?

MIMI: What's he saying?

RODOLFO: She has been ill for months now, she has a constant fever, she can't go to the doctor – she's not got leave to stay here.

MARCELLO: Is this really true?

MIMI: Am I really so ill?

RODOLFO: And the way that we live just makes it worse, my room is freezing. She sends home all her wages; you know I can't support her. If she found a rich boyfriend perhaps she could get married. I am not what she needs now – we've got no future.

MARCELLO: This is no good.

MIMI: Here's the true part.

RODOLFO: Mimi deserves much better than I'm able to give her.

MIMI: I can't stand it, every day now, "A rich boyfriend", "A rich boyfriend".

MARCELLO: You two must part.

RODOLFO: I don't have the money or the strength to stay with her.

MIMI: Why can't he believe that I want him?

MARCELLO: What a messed up life! What a messed up life.

MIMI coughs and they hear her.

RODOLFO: What, Mimi! You're here!

MARCELLO: Then she overheard you.

RODOLFO: Have you been listening? Don't bother with what I say. I get worked up at nothing. Here, come and get warm.

MIMI: No, I'm not staying very long.

RODOLFO: Ah, Mimi!

MUSETTA laughs offstage.

MARCELLO: And Musetta is laughing. Who is with her? She's always flirting! I've had enough of it. *(Exits.)*

MIMI: Goodbye then.

RODOLFO: No! Don't go.

MIMI: We both know that we can't be together Rodolfo. I was happy enough before I got to know you. I'll stay home making flowers and you've got all your friends. Goodbye then, we will be friends. Do me a favour; pack up the things that I have left in our bedroom. I don't think I could go back there, it would make me cry. I'm crying already. Just throw them in a box and when I've a flat I'll send Musetta to collect them. Listen. Next to the wardrobe you'll find the hat you bought me. Perhaps – perhaps you'd like to keep it as a reminder of me?

RODOLFO: So it really is over? If we can, let's be friend, you know I'll miss you. Goodbye then we will be friends.

MIMI: Goodbye to waking up together and not getting up.

RODOLFO: Goodbye to long days spent together, just talking for hours.

MIMI: Goodbye to all your jealous madness. Goodbye to fighting.

RODOLFO: Kisses.

MIMI: Goodbye to accusations.

RODOLFO: Though when I didn't trust you, you managed to forgive me.

MIMI: It's so depressing…

RODOLFO: It's sad…

MIMI AND RODOLFO: …to be alone in winter.

MIMI: Lonely!

MIMI AND RODOLFO: But when spring returns it doesn't seem so bad…

MIMI: …sunshine makes it better

MARCELLO: *(Offstage.)* And what do you think you're doing?

MUSETTA: *(Offstage.)* That's enough!

MARCELLO: *(Offstage.)* Yes, enough of this behaviour!

MIMI: No one's lonely in spring… and everybody seems so much more friendly.

MARCELLO and MUSETTA enter.

MARCELLO: When I came in you couldn't help looking guilty.

MUSETTA: That good-looking man was asking, "How can you be so attractive?".

RODOLFO: The sunshine makes everything brighter.

MARCELLO: You're embarrassing yourself now.

MUSETTA: I returned the compliment saying "I don't know, but tell me, how can *you* be so charming?"

MARCELLO: And you don't think that perhaps that counts as flirting?

MUSETTA: I will flirt with who I want to!

MARCELLO: You are pushing your luck now.

MUSETTA: You can piss off! You can piss off, you don't own me – I'll do anything I want to!

MARCELLO: If I thought that you were cheating! I would dump you in an instant. You're not worth this hassle, darling.

RODOLFO: In the middle of the winter you feel so lonely.

MIMI: In the middle of the winter, then you feel alone.

MUSETTA: I could never be with someone who thinks he can give me orders.

MARCELLO: You are really not that special, I won't stand here and be laughed at.

MIMI AND RODOLFO: If we just wait 'til spring time to go our separate ways, it will be easier. We will be alone then, we will part when spring is with us once again.

MUSETTA: I'll behave the way I want to! You don't like it? I don't give a toss what you think. I'll never take any orders, and so goodbye, I want freedom. Goodbye my dear!

MARCELLO: I'll replace you very quickly. Are you leaving? Thank you so much! Find someone else to give you money. Thank you so much!

MUSETTA AND MARCELLO: I don't need you, goodbye!

MUSETTA: Your paintings are crap anyway!

MARCELLO: Chav!

MUSETTA: Posh git! *(Exit.)*

MARCELLO: Bitch. *(Exit.)*

MIMI: We can make it work. We'll stay together for a little while.

RODOLFO: We'll wait 'til springtime before we say goodbye.

MIMI: I wish that winter would last forever!

MIMI AND RODOLFO: We'll stay together until spring is here.

ACT IV

April 2012. MARCELLO and RODOLFO's flat.

MARCELLO: In an MG?

RODOLFO: Driving in Bloomsbury Square. She pulled up by the pavement, "So Musetta," I asked her, "How's your heart?" *(Mimicking MUSETTA.)* "It's fine, thanks, never better. Money has stopped it from beating".

MARCELLO: I'm happy to hear that; I'm happy for her.

RODOLFO: So full of crap! You're as messed up as I am.

MARCELLO: Not beating? That's great! Guess who I saw?

RODOLFO: Musetta?

MARCELLO: Mimi.

RODOLFO: You saw her? Oh, really?

MARCELLO: Travelling by taxi and looking quite the lady of leisure.

RODOLFO: That's good, really she deserves it.

MARCELLO: You're gutted that she's not with you.

RODOLFO: We should work.

MARCELLO: Yes, to work.

They attempt to work, RODOLFO on his laptop and MARCELLO on his painting.

RODOLFO: This stupid laptop.

MARCELLO: This paintbrush is useless.

RODOLFO: Oh Mimi, I can't forget you. I can't believe I left you. You'll never come back now, I treated you so badly. Everything about you. Ah! Mimi, I didn't know my luck.

MARCELLO: I don't understand it, but whatever I'm painting my brush takes on a personality all of its own. Whenever I begin another painting, whatever it may be of, I cannot

help it, I find I am painting two dark eyes and a laughing mouth. And I have painted Musetta yet again.

RODOLFO: Ah, it's pathetic isn't it, how I have kept her hat? It brings it all back; the first time that I met her on Christmas Eve… I didn't realise how lucky I was when I was still with her, when I was still with her.

MARCELLO: Ah, if she weren't so beautiful, perhaps I could move on. I'll never replace her. She has so many others but I can't help hoping that she will come back. My pathetic heart can't seem to let her go.

RODOLFO: What is the time?

MARCELLO: Time to eat yesterday's dinner!

RODOLFO: And Schaunard hasn't come back?

SCHAUNARD: *(Enters with COLLINE carrying a bag of food.)* Here we are.

RODOLFO: What's that?

MARCELLO: Let's see, just bread?

COLLINE: It's good enough for Jamie Oliver! Have an olive.

SCHAUNARD: Delicious.

COLLINE: And all for a fiver.

MARCELLO: Even George Osborne would say you'd been prudent.

SCHAUNARD: Put the champagne to cool in the bucket.

RODOLFO: Which can I serve you? Oysters or salmon?

MARCELLO: Now sir, can I tempt you with tongue of parrot?

SCHAUNARD: Thank you. I'll pass though, I'm on a strict diet.

RODOLFO: You're going?

COLLINE: I'm rushing off to ten Downing Street!

MARCELLO: You've been invited?

RODOLFO, SCHAUNARD AND MARCELLO: Whatever for?

COLLINE: David has named me Chancellor!

SCHAUNARD, MARCELLO AND RODOLFO: Splendid!

COLLINE: This marks the start of my career.

SCHAUNARD: Here's to Colline!

MARCELLO: Colline, I'm eating!

SCHAUNARD: Dearly beloved, if I could importune you…

RODOLFO AND COLLINE: Stop it!

MARCELLO: Idiot! You're a moron.

COLLINE: Silly children! Always fighting.

SCHAUNARD: I'd like to entertain you by playing my new composition.

RODOLFO, MARCELLO AND COLLINE: No!

SCHAUNARD: Perhaps you like interpretive dancing?

RODOLFO, MARCELLO AND COLLINE: Yes please.

SCHAUNARD: Some dancing which was inspired by Strictly!

COLLINE: My favourite, let's warm up first… Ballet?

MARCELLO: Throw some shapes then!

RODOLFO: Or a lap dance?

SCHAUNARD: The tango.

COLLINE: Please, may I have the pleasure?

RODOLFO: Bow to your ladies.

COLLINE: We're ready.

SCHAUNARD: La, lera, lalera…

COLLINE and MARCELLO dance.

RODOLFO: *(Cutting in to dance with MARCELLO.)* Hey baby, you are gorgeous.

MARCELLO: You're not so bad yourself, sir.

SCHAUNARD: Lalera, la lera, la…

COLLINE: Now grope her!

SCHAUNARD: Not in my house!

COLLINE: Who says so?

SCHAUNARD: You want to pick a fight?

COLLINE: Come and get it, you'll regret it. I am ready.

SCHAUNARD: Me too, come on! *(SCHAUNARD and COLLINE playfight.)* You'll be bleeding on the floor.

COLLINE: You'll be begging me for mercy.

SCHAUNARD: It's not my fault you're a weakling.

COLLINE: Not my fault you want to die!

RODOLFO AND MARCELLO: It's disgraceful how these hoodlums don't appreciate our dancing!

MUSETTA enters.

MARCELLO: Musetta!

MUSETTA: It's Mimi, it's Mimi, I brought her with me and she's sick…

RODOLFO: Where is she?

MUSETTA: She's too weak to climb up the staircase.

RODOLFO: Ah!

SCHAUNARD: Help me move the sofa nearer.

RODOLFO: Here, some water.

MIMI enters.

MIMI: Rodolfo!

RODOLFO: Careful, you rest now.

MIMI: Oh, my Rodolfo. May I stay here with you?

RODOLFO: Stay anytime, my poor Mimi.

MUSETTA: *(To MARCELLO and COLLINE.)* I heard a rumour that Mimi's rich boyfriend had thrown her out and she had nowhere to live. Where was she? I searched and searched,

at last I found her outside in the street. I was shocked at the state of her. She told me, "I'm really ill, it's serious. Rodolfo; I want to be with him, he may be waiting. Will you take me Musetta?"

MIMI: *(To RODOLFO.)* I'm already better. Now let me see if you have changed it. No, everything is at it was. Now I'm back here, now I'm with you I feel sure that I'll get well again. You will make me well again.

RODOLFO: It's so good to have you here again, to have you near me.

MUSETTA: Have you anything for her?

MARCELLO: Nothing.

MUSETTA: Any soup? Any tea?

MARCELLO: Nothing. Only vodka!

SCHAUNARD: *(Taking COLLINE to one side.)* Colline, she's dying.

MIMI: I'm always cold now, I wish I had some gloves here. Even in summer I'm freezing. All of my fingers are numb.

RODOLFO: I'll warm them for you. Don't try to speak my darling.

MIMI: Don't worry sweetheart it's just a cough. How are you Marcello? Schaunard, Colline, how are you? It's so good to see you, it has been far too long.

RODOLFO: You must rest, do not talk.

MIMI: I'm fine now, don't worry. Marcello let me tell you, your Musetta is lovely.

MARCELLO: I know, I know.

MUSETTA: *(To MARCELLO, taking off her earrings.)* Take these, sell them and buy her something to help. And get a doctor!

RODOLFO: *(To MIMI.)* Stay still now.

MIMI: Please stay here with me.

RODOLFO: I'm here.

MUSETTA: Marcello, this may be the last thing that I can do for Mimi, she is freezing. I'll go and buy some gloves. You come with me.

MARCELLO: You're so thoughtful Musetta.

MARCELLO and MUSETTA exit.

COLLINE: Now then, my old cigarette case, while all my friends thought you were a silly affectation, between us we know better. For all these years I've known that I could rely upon your wisdom. You lived cosily in the pockets of all my jackets, I know you understand me. It's time for you to find someone else. I will miss you. It's time that you found another owner. My old friend goodbye.

Schaunard, come with me while I sell my case. We both can do something that will help Mimi. I'll sell this, and you, you should leave them alone.

SCHAUNARD: You're right, I'm being selfish. Come on, let's go.

COLLINE and SCHAUNARD exit.

MIMI: Have they gone now? I was not really sleeping; I hoped that if I pretended they would leave us. I have so many things I want to tell you, or just one thing, but it's the one that matters. Even though we have been apart for months now, my heart was here and I will always love you.

RODOLFO: Ah, Mimi, my beautiful Mimi.

MIMI: Am I really still beautiful?

RODOLFO: Beautiful as the sunrise.

MIMI: Oh no, you are mistaken. You should have said beautiful as the sunset. I'm always called Mimi, I'm always called Mimi... but I don't know why.

RODOLFO: Home to my arms came my perfect little Mimi.

MIMI: The hat you bought me! The hat you bought me. Do you remember everything that happened the first time that we met?

RODOLFO: Of course I remember.

MIMI: When all the lights had gone out…

RODOLFO: And you didn't want to stay long. And then you lost your door key.

MIMI: You said that we'd never find it in the darkness.

RODOLFO: We looked and looked…

MIMI: Come on Rodolfo, time to admit the truth now. You found it quicker than you told me!

RODOLFO: I thought you didn't like me.

MIMI: I was flattered. I thought you were very charming. "Your fingers are half frozen, let me warm them in my own." It was dark and you took my hand in yours. *(Coughs violently.)*

RODOLFO: Oh God, Mimi!

SCHAUNARD: *(Enters.)* What's wrong?

MIMI: Nothing, I'm better.

RODOLFO: Careful, please do not talk.

MIMI: Yes, yes, don't worry. I'll be good now.

MUSETTA: How is she?

RODOLFO: She's resting.

MARCELLO: I got through to the doctor, he'll come. I said to hurry – and I got this.

MARCELLO gives RODOLFO a bottle of cough medicine and MUSETTA gives him some gloves.

MIMI: Who is it?

MUSETTA: Me, Musetta.

MIMI: Oh, they're soft and beautiful! At last, at last my hands will be warm now. These will keep them nice and warm. *(To RODOLFO.)* Did you buy them for me?

MUSETTA: Yes.

MIMI: Oh! Such extravagance! Thank you, I really love them. Don't cry. I'm better. You shouldn't worry so much. My love. I love you so much. My hands are so warm now and I'm sleepy. *(She dies.)*

RODOLFO: What did the doctor say?

MARCELLO: He's coming.

MUSETTA: Oh God if you're up there, please make her better. I'm no good at praying but don't let Mimi die.

Someone bring me a blanket for Mimi, she's still shivering. Like that. Oh, please let her recover. I behave badly but she is always kind to everyone, and she's so young still, she has so much life left.

RODOLFO: I think she's better, but do you think it's serious?

MUSETTA: She'll be fine.

SCHAUNARD: Marcello, she's dead.

COLLINE: *(Enters.)* Some money for her. How is she?

RODOLFO: Look, she's asleep. *(Seeing the expression on MARCELLO's face.)* What's the matter? Why are you staring at me like that?

MARCELLO: Rodolfo…

RODOLFO: *(Going to MIMI and realising she is dead.)* Mimi! *(Sobbing.)* Mimi…